PRACTICAL ART

WATERCOLOUR

A STEP-BY-STEP GUIDE TO WATERCOLOUR TECHNIQUES

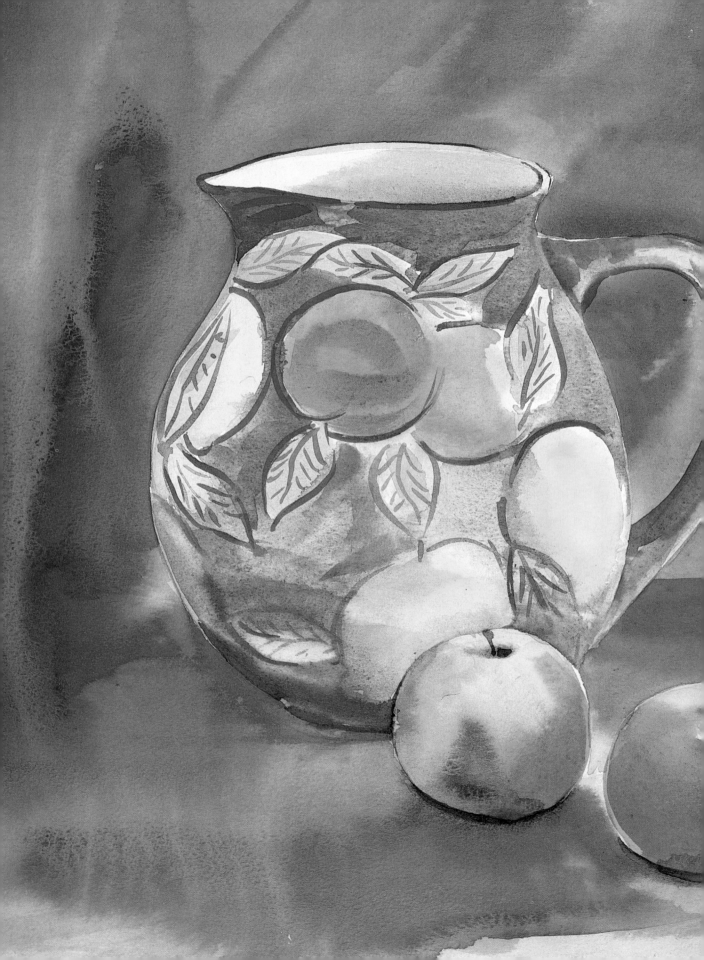

PRACTICAL ART

WATERCOLOUR

A STEP-BY-STEP GUIDE TO
WATERCOLOUR TECHNIQUES

ANGELA GAIR

TIGER BOOKS
INTERNATIONAL
LONDON

First published in 1994
by Letts of London
an imprint of New Holland (Publishers) Ltd
London · Cape Town · Sydney · Singapore

24 Nutford Place
London W1H 6DQ
United Kingdom

80 McKenzie Street
Cape Town 8001
South Africa

3/2 Aquatic Drive
Frenchs Forest, NSW 2086
Australia

Reprinted 1995

This edition published in 1997 by Tiger Books International Plc,
Twickenham

ISBN 1 85501 871 3

A CIP catalogue record for this book is available from the British Library

Editorial Director: Joanna Lorenz
Project Editor: Judith Simons
Designed and Typeset by: Axis Design
Photographer: Ken Grundy

Reproduction by J Film Process (S) Pte Ltd
Printed and bound in Malaysia by Times Offset (M) Sdn Bhd

ACKNOWLEDGEMENTS
Special thanks are due to Winsor & Newton, Whitefriars Avenue,
Harrow, Middlesex, for providing the materials and equipment featured
and used in this book; Sean Kelly Gallery, 21 London Road, London, for
supplying additional materials; Chris Beetles Ltd, 8-10 Ryder Street,
London SW1; Linda Blackstone Gallery, 13 High Street, Pinner,
Middlesex; and Annie Wood for her invaluable help.

CONTENTS

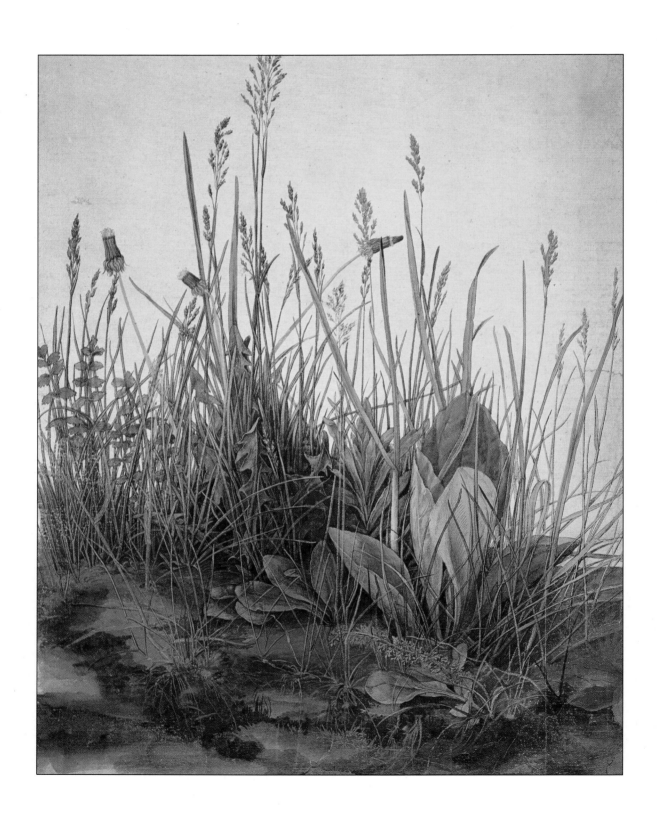

INTRODUCTION

There can be few things which are more unpredictable or satisfying than working in watercolour. The unique freshness and delicacy of the medium, its ability to produce breathtaking images with just a few brief strokes, have fascinated painters for centuries.

Water-based paint has its origins in prehistoric times. Stone Age man depicted animals and hunting scenes on the walls of cave-dwellings using pigments mixed from natural earth colours – yellow and red ochres, and black made from carbon – which were bound with animal fat and diluted with water.

Ancient Egyptian artists used water-based pigments on plaster to paint decorative reliefs on the walls of their palaces and tombs. They used mainly red, blue, green, black and white pigments, derived from minerals which were ground in water and bound with starch or honey. The colours are as fresh and intense today as they were thousands of years ago.

Water-based paints rose to prominence with the fresco paintings of the Renaissance artists of fifteenth- and sixteenth-century Florence. Fresco painting involved applying pigments mixed with water directly onto wet plaster. As the plaster dried, the colour was bonded into it and became part of the wall, instead of lying on the surface. The ceiling of the Sistine Chapel, painted by Michelangelo (1475–1564), is one of the largest and grandest frescoes ever painted.

The German Renaissance artist Albrecht Dürer (1471–1528) painted meticulous studies of plants, flowers and animals. As was the practice at the time, he used opaque watercolour to give his botanical works substance and clarity. But he was also one of the first painters to exploit the transparency of watercolour. Among his numerous paintings are delicate landscapes composed of thin layers of colour applied in swift, spontaneous brush strokes. These have a wonderfully

The Great Piece of Turf *Albrecht Dürer*

Dürer was the first European artist to exploit the transparent qualities of watercolour. His technical skill as an engraver is reflected in this meticulously detailed watercolour study of a clump of grass and wild flowers, which combines thin washes of colour, pen-and-ink line, and touches of body colour.

A City on a River at Sunset *J M W Turner*

This small study is one of many that Turner produced in preparation for a series of engravings to illustrate the "Great Rivers of Europe". Breathtakingly economical in its evocation of place and atmosphere, it is painted in transparent watercolour and body colour on blue paper.

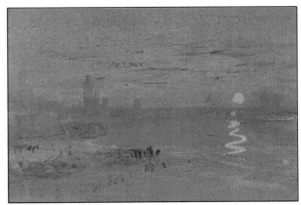

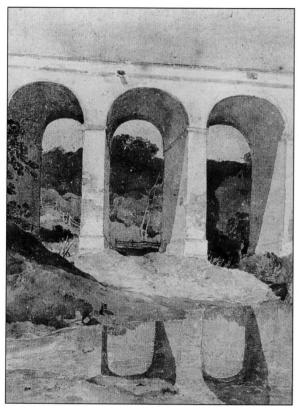

Chirk Aqueduct *John Sell Cotman*

This image leaves an indelible imprint on the mind, such was Cotman's skill in balancing and controlling colour, line, tone and mass. Laying down crisp washes of clear, luminous colour, he created a pattern of simple, interlocking areas of light and dark tone that effectively convey the weight and bulk of the enormous structure.

free quality which anticipates by several centuries the work of watercolour masters such as Turner and Cézanne.

Inexplicably, watercolour fell into obscurity after Dürer's death, and throughout the sixteenth and seventeenth centuries it was mainly used for making preliminary studies, roughs and sketches for oil paintings.

During the eighteenth century watercolour at last began to be recognized as a medium in its own right. By the late eighteenth and nineteenth centuries watercolour painting had become enormously popular and something of a British speciality, due in part to the emergence of "The Grand Tour". As Britain grew more prosperous and outward-looking, it became fashionable for the sons of wealthy families to travel through continental Europe in order to broaden their education. These young tourists often took watercolour painters along with them

to paint the classical ruins and picturesque scenes they visited.

The two greatest watercolour painters of the eighteenth century were Thomas Girtin and J M W Turner. Girtin (1755–1802) broke away from the accepted conventions of watercolour painting, in which preliminary outlines were "filled in " with a grey underpainting, over which washes of colour were carefully laid. Girtin painted directly onto white paper, thus allowing light to reflect off the paper and enhance the transparent brilliance of the colours. He used a strictly limited palette of five basic colours – yellow ochre, burnt sienna, light red, monastral blue and ivory black – with which he created subtle harmonies of tone. Girtin was one of the first watercolourists to paint directly from nature, braving all conditions in his desire to capture the transient and fluctuating effects of light and weather.

Joseph Mallord William Turner (1775–1851) was another iconoclast, who opened the way for artists to interpret their own sensations before nature. Turner explored the dynamic and sensuous elements of nature – storm and wreck, wind, sky and water, the shimmering light of Venice, misty mountains, rivers and lakes at sunset. In his preoccupation with colour and light he splashed, dragged, scratched and pushed the wet paint around, literally bending the medium to his will.

The golden age of British watercolour painting continued well into the nineteenth century with the work of such notable luminaries as John Sell Cotman (1782–1842), John Varley (1778–1842), Samuel Palmer (1805–1881) and others too numerous to mention.

Meanwhile, watercolour painting was also flourishing in America. Winslow Homer (1836–1910) and Thomas Eakins (1844–1916) are synonymous with the realist tradition, continued in the twentieth century by Edward Hopper (1882–1967). Some of the more avant-garde artists left America for Europe, where they exerted considerable influence. James Abbott McNeill Whistler (1834–1903) was a master of the technique known as "wet–into–wet", in which colours are flooded onto the paper and fuse together into semblances of water, sky or trees. Influenced by Japanese art, he captured the essentials of a scene with breathtaking skill and economy of means. John Singer Sargent (1856–1925) showed equal skill in his use of expressive brush strokes to capture the shifting effects of sunlight and shadow.

The artist who revolutionized modern watercolour painting was Paul Cézanne (1839–1906). Although loosely associated with the Impressionists, Cézanne was less interested in the ephemeral effects of nature than in its solidity and permanence. Believing that drawing and colour are inseparable, he interwove colour and line, applying one over the other for a unity of effect. In his later career he turned increasingly to watercolour, exploiting its qualities to describe the volume of objects with successive washes of pure colour and using the direction of the brushmarks to "sculpt" their contours.

During the twentieth century watercolour has played its part in the numerous experimental art movements that have evolved over the decades. In particular, abstract and expressionist painters including Wassily Kandinsky (1866–1944), Emil Nolde (1867–1956) and Paul Klee (1879–1940) found the unpredictable quality of watercolour an ideal medium for expressing their highly personal visions.

Watercolour continues to flourish in the traditional vein, but at the same time has escaped the strict confines of the purist approach formulated in the eighteenth century. Today, watercolour may be combined with other media – gouache, acrylics, pastel, collage – without raising a disapproving eyebrow. Infinitely versatile and adaptable, it appeals to die-hard traditionalists and avant-garde sophisticates alike. Its future as a leading paint medium is assured.

The Waterfan *Winslow Homer*

In his later career, Homer painted extensively in the Bahamas and Bermuda. In his seascapes and landscapes he recorded both the ethereal light of the tropical storms and the vibrant colour present on clear days.

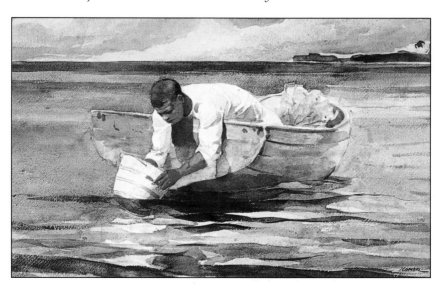

MATERIALS AND EQUIPMENT

The range of watercolour paints and equipment on display in art supply stores is quite daunting. Yet one of the advantages of watercolour painting is that it requires few materials – many a masterpiece has been created with just a few colours, a couple of brushes, a jar of water and a sheet of paper. This section outlines all the paints and equipment you will need when you first start.

PAINTS

Watercolour paints are available in tubes of creamy paint and in small blocks of semimoist colour called "pans". There are two grades – "artist's" and "student's". The student's range is cheaper, but you will get better results from the artist's range, which contains finer quality pigments.

Tube colour is richer than pan colour and is useful for creating large areas of wash quickly; simply squeeze the paint onto a palette and mix it with water. The only disadvantage is that the paint can leak and solidify if the cap is not replaced properly after use.

Pans can be bought individually as well as in special paintboxes with slots to hold the pans in place and a lid which opens out to form a convenient mixing palette. They are economical to buy and useful for outdoor work as they are easily portable. However, it takes a little effort to lift enough colour onto the brush to make a large wash.

Gouache is an opaque type of watercolour made by binding the pigments with gum arabic and combining them with white chalk. The paint dries to an opaque, matt (flat) finish, quite different to the delicate transparency of pure watercolour, yet watercolour and gouache can be used together in the same painting with great success.

Suggested Palette

You do not need a large number of colours to paint expressive pictures. Most artists use a basic palette of pigments that forms the backbone of their work, augmented by additional pigments if they are needed for a particular subject. Keeping to a small range of pigments encourages you to mix them together to create a range of subtle hues, while at the same time achieving a harmonious painting.

There is no definitive basic palette; every artist will, of course, have their own special favourites. However, the colours described and illustrated on page 11 should meet most requirements.

SUGGESTED PALETTE

Cadmium yellow pale
A strong bright warm yellow, very useful in mixes. When mixed with viridian it produces soft, warm greens.

Cadmium red pale
A warm, intense red. Produces good pinks and purples when mixed with other colours.

Alizarin crimson
A cool, slightly bluish red; diluted it creates delicate pinks. Mixed with ultramarine, it produces a pure violet.

Cobalt blue
Gentler and more subtle than French ultramarine, it is wonderful for skies.

French ultramarine
A dark, subdued blue with a faint hint of violet. Mixes well with yellow to form a rich variety of greens and with brown to form interesting greys.

Viridian
This deep, rich green retains its brilliance, even in mixes. Ideal for cooling reds, it also mixes well with burnt sienna to create a useful shadow colour.

Sap green
A lovely, resonant green that provides a wide range of natural greens and browns in mixes — ideal for landscape colours.

Yellow ochre
A soft yellow, very useful in landscape painting. Produces soft, subtle greens when mixed with blues.

Burnt sienna
A gentle, dark and transparent brown. Mixes well with other pigments to create muted, subtle colours.

Burnt umber
A rich and versatile brown, ideal for darkening colours.

Payne's grey
Made from a mixture of blue and black, this is a good all-round colour. In mixes, it produces intense shadows that are still full of colour.

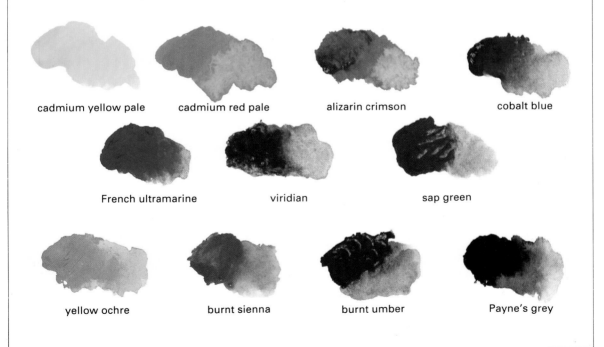

cadmium yellow pale cadmium red pale alizarin crimson cobalt blue

French ultramarine viridian sap green

yellow ochre burnt sienna burnt umber Payne's grey

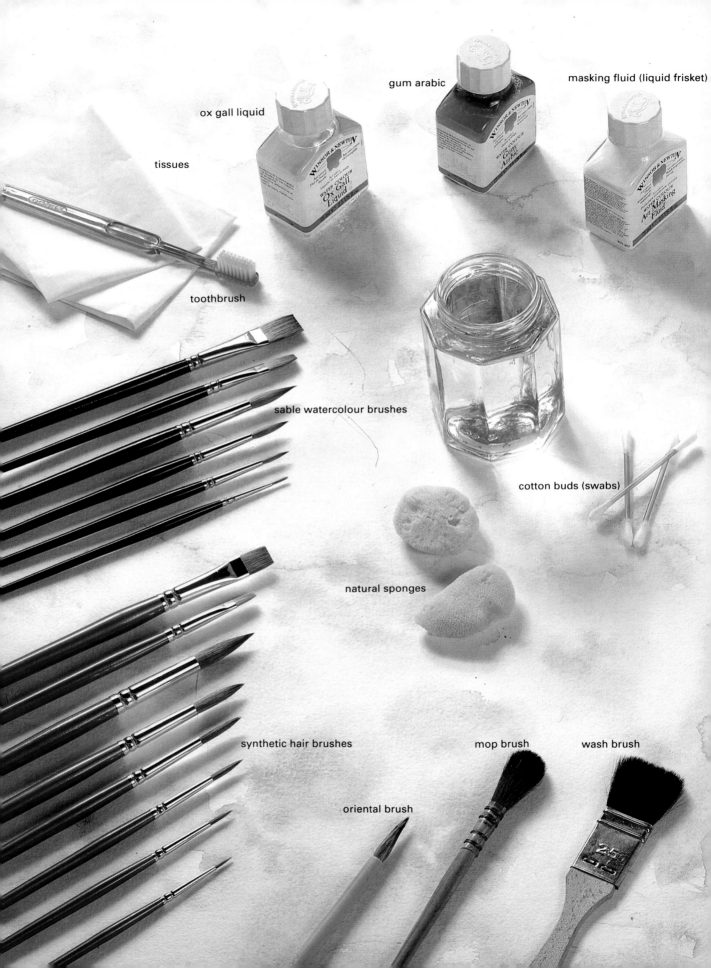

ox gall liquid

gum arabic

masking fluid (liquid frisket)

tissues

toothbrush

sable watercolour brushes

cotton buds (swabs)

natural sponges

synthetic hair brushes

mop brush

wash brush

oriental brush

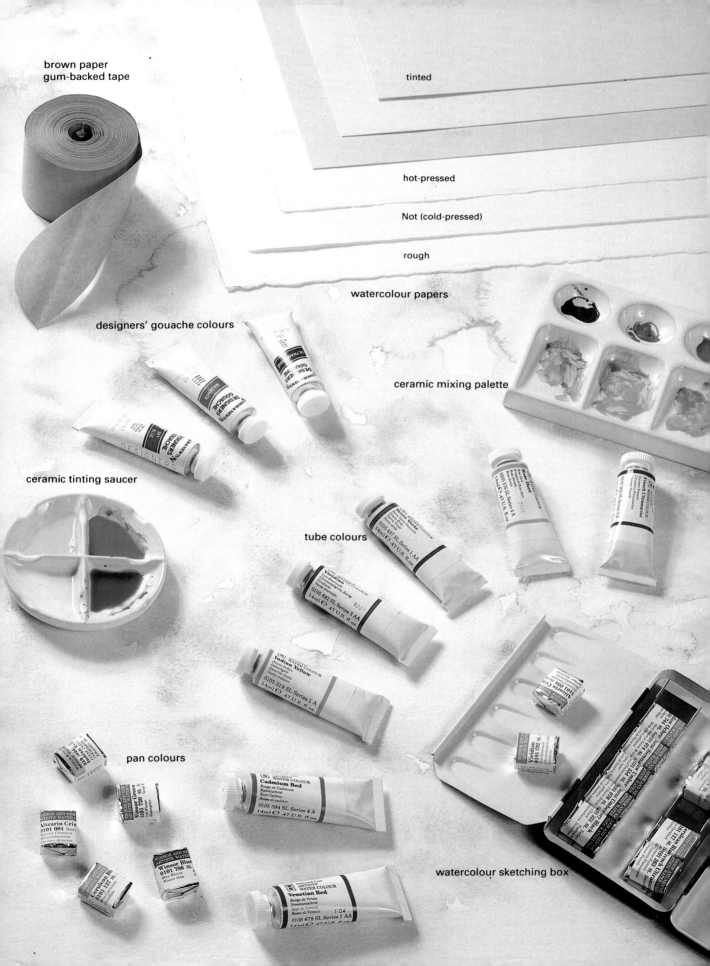

brown paper
gum-backed tape

tinted

hot-pressed

Not (cold-pressed)

rough

watercolour papers

designers' gouache colours

ceramic mixing palette

ceramic tinting saucer

tube colours

Indian Yellow

pan colours

Cadmium Red

watercolour sketching box

BRUSHES

Brushes are especially important in watercolour painting, so it is worth buying good quality ones. Sable brushes are expensive, but they give the best results and will last for many years. They are resilient, hold their shape well, do not shed their hairs, and have a springiness which results in lively, yet controlled brush strokes.

Sable blends – sable mixed with other hairs such as squirrel, ox hair or synthetic fibres – are a less expensive alternative that will give you perfectly good results. Bamboo-handled Oriental hog's hair brushes are inexpensive and versatile; the full-bodied head holds plenty of paint and also points well for painting fine details.

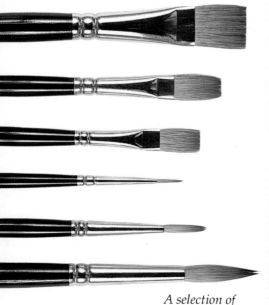

A selection of round and flat sable brushes in a range of sizes.

Brush Shapes

There are two basic shapes for watercolour brush heads: rounds for painting small areas and detail; and flats for applying broad washes.

Rounds are bullet-shaped brushes that come to a fine point. By moving the broad side of the brush across the paper you can paint sweeping areas of colour, and with the tip you can paint fine details. Flats are wide and square-ended. They are ideal for spreading water rapidly over the paper to create a wash. The flat edge is useful for making clean-cut lines.

Brush Sizes

Brushes are graded according to size, ranging from as small as 0000 to as large as 14. The size of flats generally denotes the width of the brush, measured in millimetres or inches.

Three or four brushes are enough to start with; choose a small round for fine detail, a large flat for laying washes, and a medium-sized round and flat for general work.

Brush Care

Look after your brushes and they will last a long time. When painting, try not to leave brushes standing in water as this can ruin both the hairs and the handles. When you have finished painting, rinse brushes in running water, making sure that any paint near the metal ferrule is removed.

After cleaning, shake out the excess water and gently re-form the brushes to their original shapes, then either lay them flat or place them head-upwards in a jar to dry. If you store wet brushes in an airtight container, mildew will develop. Moths are very keen on sable brushes, so if you need to store brushes for any length of time, use some mothballs to act as a deterrent.

PAPER

A wide variety of watercolour paper is available, both in single sheets and, more economically, in pads and blocks. The choice of paper depends largely on the subject, the technique used, and the effect required. Paper varies in surface texture and in weight (thickness). The surface texture of paper is known as its "tooth". There are three kinds of surface:

Hot-pressed (HP) is very smooth, with almost no "tooth". It is suitable for finely detailed work, but most artists find its surface too slippery for pure watercolour painting.

Not, meaning not hot-pressed (cold-pressed), is the most popular type of surface, and is ideal for less experienced painters. Its medium-textured surface is good for both large, smooth washes and for fine brush detailing.

Rough paper has a pronounced "tooth" which catches at the brush and causes watercolour strokes and washes to break up. The paint sinks into the pitted surface and leaves speckles untouched, producing a luminous sparkle.

Traditionally, the weight of paper is measured in pounds (lb) per ream (480 sheets). The equivalent metric measure is grams per square metre (gsm). As a guide, the lightest watercolour paper is 150gsm (70lb), while a heavier grade is 300gsm (140lb). The heaviest paper weighs 640gsm (300lb). Paper tends to cockle (buckle or warp) when wet, and the lighter the paper, the more it cockles. This problem is avoided by stretching it before use (see pages 18–19).

Prepared boards consist of thin watercolour paper ready-mounted on thick cardboard, which is convenient as stretching is unnecessary.

Watercolour blocks consist of sheets of paper stuck together on the edges of all four sides to prevent cockling. They are very useful when you do not want the bother of stretching paper or when you are working outdoors. When the painting is finished you simply tear off the top sheet.

PALETTES

If you are using pan colours, the box in which they are kept doubles as a palette, because the inside of the lid has wells for mixing colour. You can buy recessed palettes for tube colours with separate mixing wells which slant so that the paint collects at one end ready for use. Tinting saucers are useful for mixing large amounts of colour; these are small ceramic dishes, either divided into four compartments for laying out

separate colours or undivided for a single colour. You could also try improvising with an old white china plate, which will give you plenty of room for mixing.

ACCESSORIES

You will need a soft pencil (3B or 2B) for drawing; a kneaded putty eraser for erasing pencil lines without spoiling the surface of the paper; soft tissues or a natural sponge for mopping up excess water and lifting out colour, and also for applying paint when you want a textured effect; cotton buds (swabs) for lifting small areas of colour; jars for water; a drawing board; brown paper gum-backed tape for stretching paper; and masking fluid (liquid frisket) for reserving light or white areas in a painting.

A china hors d'oeuvres dish is an excellent alternative to recessed palettes or tinting saucers, especially if mixing large amounts of paint; separate colours or tones can be mixed in each section.

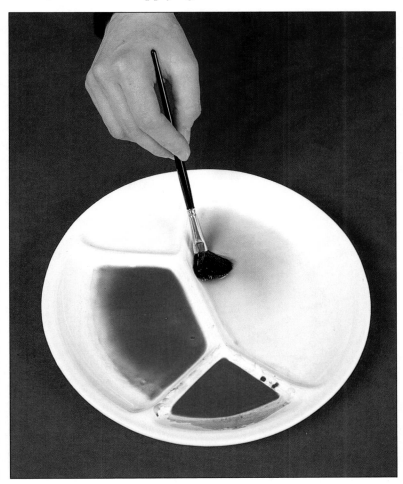

BASIC TECHNIQUES

MIXING PAINT

You can use almost any non-absorbent white surface as a palette for watercolour paint; in fact, when mixing a wide range of colours you may find an old white china plate gives you more room than a standard watercolour palette.

Watercolour paint always dries lighter on the paper than it appears when wet, so mixing is often a matter of trial and errror. It is impossible to tell by looking at the paint on a palette whether the colour or shade is right: the colour must be seen on the paper. Therefore, when mixing, you should always have a spare piece of the selected paper ready for testing the colours before committing them to the actual painting.

Always mix more paint than you think you will need; it is surprising how quickly it is used up. This applies particularly to watercolour washes, which need a lot of paint; it is frustrating to run out of colour half-way through an expansive sky wash, for example. And if you run out of a particular mixed colour, you may find it

If you find a certain colour mixture successful for a particular subject, keep a note of it for future reference. This test piece relates to the project painting shown on page 58. It provides a useful – and very attractive – visual record of the colours used for various elements of the painting.

Make a page of brush marks to discover what your brushes are capable of. These marks were made with a round brush (top row) and a flat brush (bottom row).

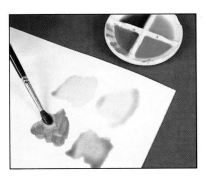

Watercolour dries lighter than it appears when wet, so test each colour on spare paper before applying it to the actual picture.

extremely difficult to match the exact colour again.

When using tube colours, squeeze a small quantity of paint onto the palette. Then pick up a little of the paint on the brush, transfer this to the mixing dish and add water, a little at a time, until you have achieved the required strength of colour. With pan colours, moisten the paint with a brush to release the pigment, then transfer the colour to the palette (or use the wells set in the inside lid of the paintbox) and mix it with water to the strength required.

Try to keep your colours fresh and clean at all times. Rinse your brush each time you use a new colour, and replace the water in your jar frequently as dirty water contaminates the colours and mutes their brilliance.

BRUSH STROKES

In oil and acrylic painting the thick paint is normally applied with stiff bristle brushes in a series of choppy strokes. The watercolour technique is quite different, requiring fluid, gliding movements to form continuous strokes. Unless you are painting fine details, move your whole arm to create flowing strokes. Keeping your painting hand relaxed, hold the brush around the middle of the handle. If you paint from the wrist as though you were writing with a pen, the strokes will be stiff and cramped.

Try out different brush techniques using both round and flat brushes, like those illustrat-

STRETCHING WATERCOLOUR PAPER

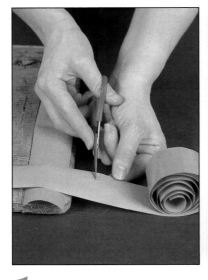

1
Cut four strips of brown paper gum-backed tape to length.

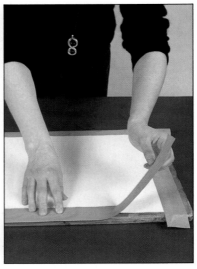

2
Immerse the paper in cold water for a few seconds.

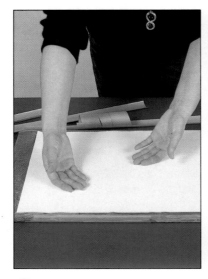

3
Lay the paper flat on the board. Smooth it out from the centre using the backs of your hands.

4
Stick down the edges of the paper with the strips of gummed tape and leave to dry.

ed here. The pressure exerted with the brush controls the width of the stroke. For fine strokes, the tip of the brush should glide across the paper. To make wider strokes, press down with the brush.

As well as short strokes, try making long, flowing ones. Painting a long stroke is similar to a follow-through in golf or tennis. Keep your hand and arm moving before, during and after the brush stroke.

You will find that the texture and absorbency of the paper will influence the marks you make. The surface of rough paper produces friction which breaks up the stroke, producing a lively, sparkling effect (see drybrush painting, pages 80–87). Conversely, a smooth paper will yield smooth lines because the brush glides easily over its surface.

STRETCHING PAPER

Most papers will cockle (buckle or wrinkle) when they become wet with watercolour paint. This can be avoided by stretching paper before starting to work on it. The paper is first soaked in water, allowing it to expand, and is then fastened down securely to a board so that it dries taut.

Have ready a drawing board, a sheet of watercolour paper, trimmed all round to about 2.5cm (1in) smaller than the drawing board, a sponge, and four strips of brown paper gum-backed tape, cut 5cm

LAYING FLAT WASHES

1

Mix up plenty of your chosen colour; the paint should be fluid but quite strong in hue.

2

Tilt the board slightly. Lay a band of colour across the top of the paper. Then continue down the paper with overlapping strokes, working in alternate directions and picking up the excess paint from the previous stroke each time.

3

Finally squeeze out the brush and soak up the excess colour at the base of the wash. Leave the wash to dry in the same tilted position.

(2in) longer than each side of the paper.

Immerse the paper in cold water — you can do this in a sink, a bath or a photographer's developing tray. The soaking time depends on the weight (thickness) of the paper; lightweight papers will require no more than a minute, heavier papers perhaps a couple of minutes. Hold the paper by one corner and shake off the surplus water gently. Lay the paper on the drawing board, smoothing it out carefully from the centre to make sure it is perfectly flat.

Working quickly, moisten the gummed paper strips with a wet sponge and stick them along each edge of the paper so that two-thirds of their width is attached to the drawing board and one-third to the paper. This ensures that the paper will not pull away from the board as it dries. Tape one side of the paper first, then the two adjacent sides, and finally the remaining side, opposite to the first strip.

Allow the paper to dry flat, away from direct heat, for several hours. As the paper dries, it will shrink and become taut. Do not use until it is completely dry. When working with a lot of water the paper may still cockle slightly; don't worry, it will dry smooth again.

LAYING WASHES

There are three basic types of wash: the flat wash, the gradated wash and the variegated wash. All of these can be applied on either a dry or a

damp surface, although the latter helps the wash to flow more evenly.

Washes must be applied quickly and in one go, so mix up plenty of paint – you always need more than you think. The colour should be fluid, but quite strong, to compensate for the fact that it will dry much lighter on the paper. Tilt the board slightly to allow the wash to flow downwards.

Flat Wash
A flat wash is so called because it is all the same tone. To lay a flat wash, first moisten the stretched paper. Then load a large flat or round brush with paint and take it across the paper in one stroke. A bead of paint will form along the bottom of the stroke.

Load your brush again and, working in the opposite direction, lay another stroke beneath the first, slightly overlapping it and picking up the bead of colour. The excess paint will reform along the base of the second stroke. Continue working down the paper in alternate directions until the whole area is covered. Then squeeze the excess paint out of the brush with your fingers and stroke the bottom band again lightly to pick up the excess colour.

Let the wash dry in the same tilted position, otherwise the paint will flow back and dry leaving an ugly tidemark. The wash should be flat, transparent and consistent in both tone and colour.

Gradated Wash
A gradated wash starts with strong colour at the top, gradually lightening towards the bottom. The method of application is exactly the same as for a flat wash, except that with each successive stroke, the brush carries more water and

LAYING GRADATED WASHES

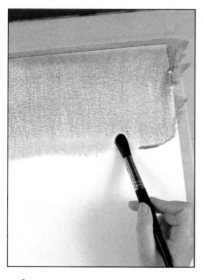

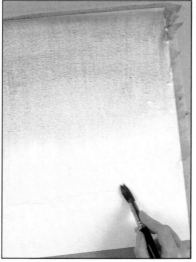

1
Lay a band of full-strength colour across the top of the paper. Lighten the colour with more water and lay another band under the first, picking up the paint at the bottom of the first band.

2
Continue in this way, applying increasingly diluted tones until you reach the bottom of the paper.

3
Leave the wash to dry in a tilted position.

less pigment. Gradated washes are very useful when painting skies, where the colour is most intense at the zenith and fades gradually towards the horizon.

It takes a little practice to achieve an even gradation with no "stripes". The secret is to keep the paint as fluid as possible so that each brush stroke flows into the one below.

Moisten the area to be painted, and tilt the board at a slight angle. Load a large brush with paint at full strength and lay a band of colour across the top of the paper, taking care not to lift the brush until you reach the end of the stroke. Don't hesitate. Quickly add more water to the paint in the palette and run the brush under the first line of colour, picking up the paint which has run down to the base of the first band. Repeat this process. Each succeeding stroke will get weaker by adding increasing amounts of water and the wash will become paler as it reaches the bottom of the paper.

Variegated washes are similar to gradated washes, except that several different colours are used instead of just one. This technique is very effective in skies and landscapes as demonstrated in the project commencing on page 74.

SQUARING UP

You may wish to base a watercolour painting on a small sketch or a photographic image; but it is often difficult to maintain accuracy when enlarging a reference source to the size of your working paper. A simple method of transferring an image in a different scale is by squaring up (sometimes called scaling up).

Using a pencil and ruler, draw a grid of equal-sized squares over the sketch or photograph. The more complex the image, the more squares you should draw. If you wish to avoid marking the original, make a photocopy of it and draw the grid onto this. Alternatively, draw the grid onto a sheet of clear acetate placed over the original, using a felt-tip pen.

Then construct an enlarged version of the grid on the sheet of watercolour paper, using light pencil marks. This grid must have the same number of squares as the smaller one. The size of the squares will depend on the degree of enlargement required: for example, if you are doubling the size of your reference material, make each square twice the size of the squares on the original.

When the grid is complete, transfer the image that appears in each square of the original to its equivalent square on the new paper. The larger squares on the new paper serve to enlarge the original image. You are, in effect, breaking down a large-scale problem into smaller, manageable areas.

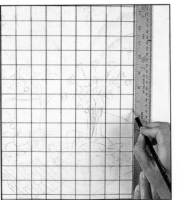

1

Draw a grid of squares onto a sheet of tracing paper laid over the reference sketch.

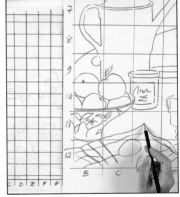

2

Lightly draw a grid of larger squares onto the watercolour paper and transfer the detail, square by square.

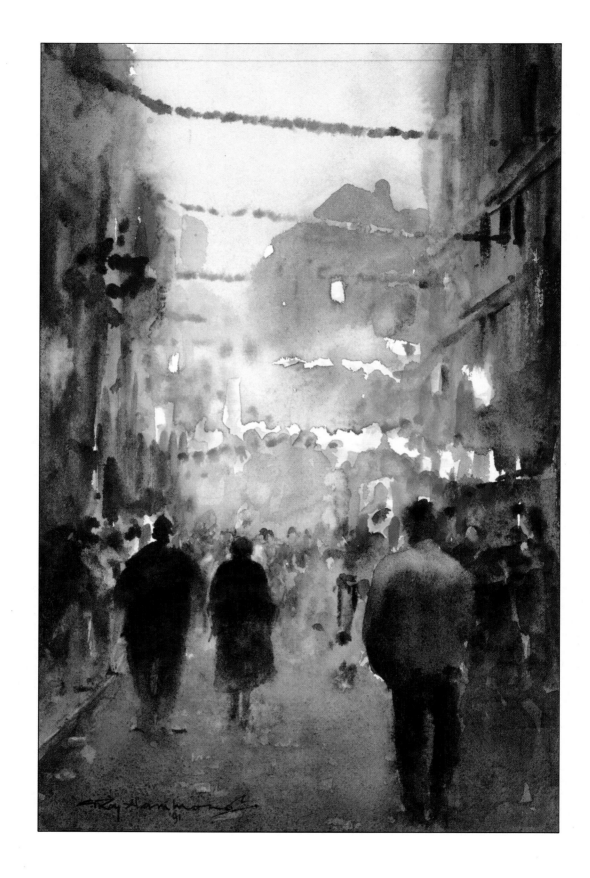

GALLERY

Watercolour is such a responsive and versatile medium that no two artists need use it in exactly the same way. On the next few pages you will find a selection of watercolour paintings by contemporary artists, which have been chosen to illustrate the diversity of artistic expression that can be achieved. The paintings encompass a broad range of techniques, which are fully explained and demonstrated in the step-by-step projects that follow.

It is always interesting and instructive to study the work of other artists, and analysing their methods can act as a stimulus in developing your own artistic language. After all, we should not be surprised to learn that all of the great masters of art were themselves inspired and influenced by the work of previous masters.

~

Street Party to Celebrate the Sardine Season, Lisbon

Roy Hammond

25 x 17cm (10 x 6½in)

Hammond has concentrated on the light in this scene, capturing the moment when the day ends and night is about to fall. He conveys the soft, hazy twilight by working almost entirely wet-into-wet, with a few small details added at the dry stage. The gaily coloured electric lights gain luminosity by contrast with the cool, shadowy tones in the street below.

Afternoon Sun

Geraldine Girvan

18 x 27cm (7 x 10½in)

It takes courage to plunge straight into a watercolour painting without first making an underdrawing. Girvan, however, enjoys the knife-edge thrill of working directly onto dry paper with wet washes, unconstrained by a pencil outline. With this intuitive approach she has captured the essential character of her cat basking in the sun.

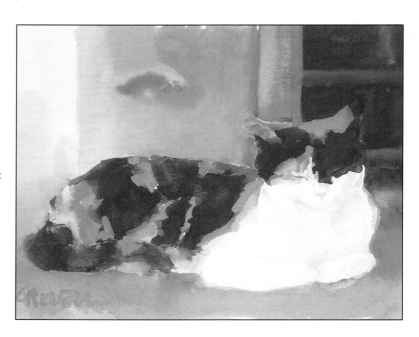

Fred and Edna

David Curtis

25 x 20cm (10 x 8in)

This expressive and amusing portrait is based on a drawing done on site. It has a fresh, spontaneous feel, yet it was painted using the classical watercolour technique of methodically building up glazes and washes over a careful underdrawing, using a limited palette. To preserve the clear brilliance of the colours, it is important to allow each wash to dry before applying the next.

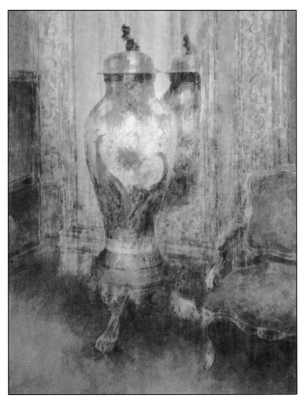

In the Ballroom, Polesden Lacey

Pauline Fazakerley

53 x 34cm (21 x 13½in)

The all-enveloping atmosphere of light in this painting is achieved by floating on many washes of thin colour. As the work progresses, the washes become smaller, finally ending in tiny overlaid dabs. As in the painting below, the impression of light is derived solely from the white paper glowing through the transparent layers of pigment, and no body colour is used.

Jug and Bowl

Sue Read

30 x 38cm (12 x 15in)

This painting has a mood of stillness and calm, of quiet introspection, engendered by the beautifully balanced composition, the neutral, almost monochromatic colours and the cool, subdued light. Read works very closely from her subject, observing every nuance of tone and colour. No body colour is used here – the colours are applied in transparent layers, with the highlights left as untouched paper.

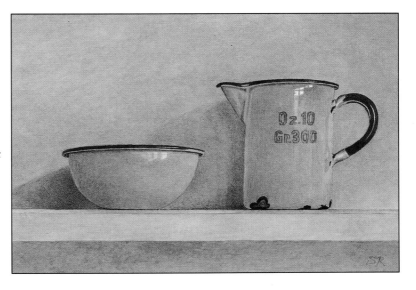

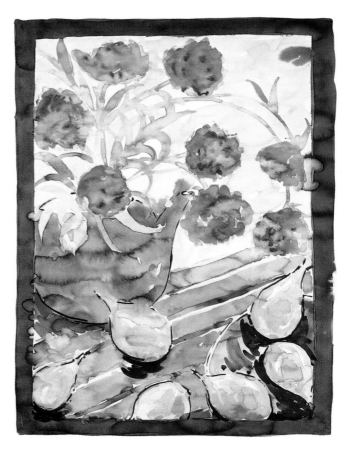

Peonies and Pears

Annie Wood

80 x 56cm (31½ x 22in)

The fluid, quicksilver nature of watercolour is exploited to the full in this still-life painting. Wood works rapidly and on a large scale, brushing great pools of colour onto damp paper without waiting for one wash to dry before applying the next. Some washes have run together, creating blotched marks known as backruns, and these are deliberately used to suggest texture and pattern.

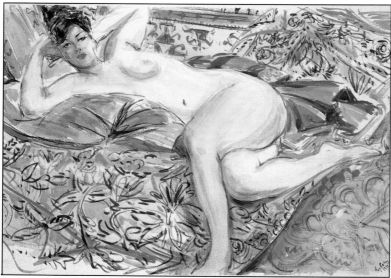

Mattia on a Kashmiri Shawl

Kay Gallwey

38 x 56cm (15 x 22in)

This decorative composition of a nude reclining on a couch has an elegance and exuberance reminiscent of the Fauve painters Henri Matisse and Raoul Dufy. The voluptuous form of the nude is in strong contrast to the Oriental pattern of the shawl, which Gallwey suggests with animated lines rapidly drawn with the tip of the brush.

The Taj Mahal, Agra (1905), Souvenir of Albert Goodwin

Roy Hammond

36 x 53cm (14 x 21in)

When Hammond is in need of inspiration, he turns to his favourite 19th-century artists. This beautiful sunset is an interpretation in watercolour of an oil painting by the painter Albert Goodwin (1845–1932). The dark tones in the landscape counterpoint the brilliant colours in the sky, while the brightest area of all – the setting sun – is suggested by small patches of untouched paper.

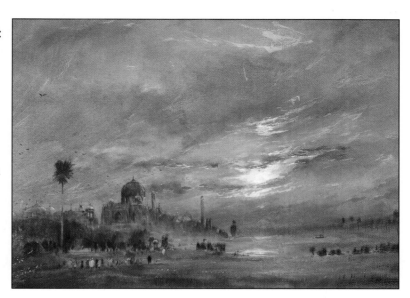

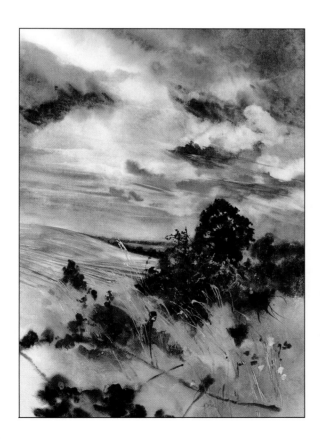

Stubble Fields and Brambles

Tony Porter

57 x 37cm (22½ x 14½in)

Porter deliberately seeks out the wild and empty places, eery under the cold northern light and buffeted by the coastal winds, of his native East Anglia. He always paints on location, flooding his colours onto very wet hot-pressed paper and allowing the paint itself to express, with great eloquence, the spirit of the place.

The River Tweed at Melrose

Ronald Jesty

34 x 57cm (13½ x 22½in)

A "drop gate" – used to prevent cattle wandering from one field into another by wading through the shallows – is the subject of this bold composition. Jesty has worked up from the lightest to the darkest tones with a series of carefully planned, minutely executed washes. The control and subtlety exercised here – the drop gate was painted without the aid of masking techniques – indicate the considerable technical skill of the artist.

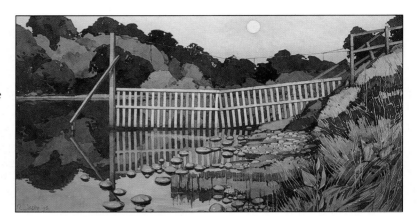

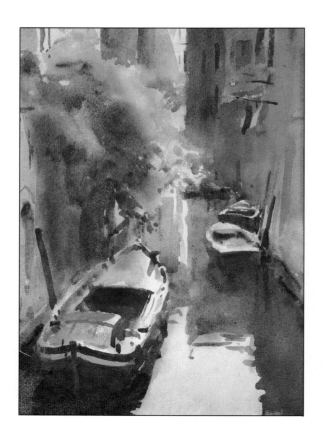

Venetian Barge

Trevor Chamberlain

25 x 17cm (10 x 6½in)

Chamberlain is particularly interested in the effects of atmosphere and light, and always works from life in the open air. The still calm of late afternoon is beautifully described by means of limpid washes that melt softly into each other, and the mood is underlined by the restrained harmony of the colour values.

Women by the Water

Lucy Willis

25 x 34cm (10 x 13½in)

Freshness and clarity are the keynotes of this lovely painting. Willis keeps her colours fresh and clear by allowing her brush strokes and washes to settle undisturbed, and this means establishing the tonal and colour values in advance so that they can be applied with confidence. The impact of this image stems from the contrast of the small sunlit area, surrounded and emphasized by the dark tones of the trees and water.

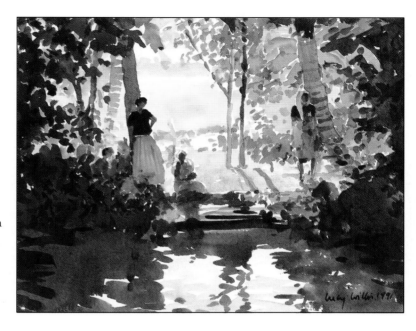

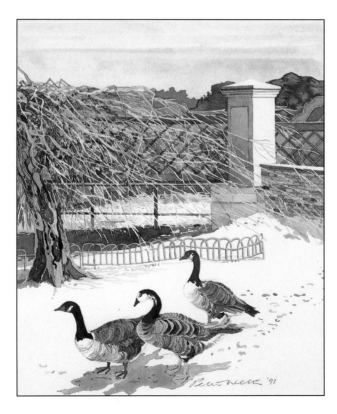

Geese Wintering in Regents Park

Peter Welton

29 x 22cm (11½ x 8½in)

Welton has his own highly individual style of painting. He never pre-draws outlines, preferring to feel his way into the painting and invent it as he goes along; this painting was based on various photographs of the geese, the bridge and the tree, taken at different times. He applies the paint very thin and very wet, literally staining the paper with coloured water. Far from appearing weak, the colours derive a clarity and brilliance from the light-reflecting surface of the paper beneath. To maximize the potential of juxtaposed colours, each one is allowed to dry before its neighbour is applied, and not a sliver of white paper is allowed to appear between them.

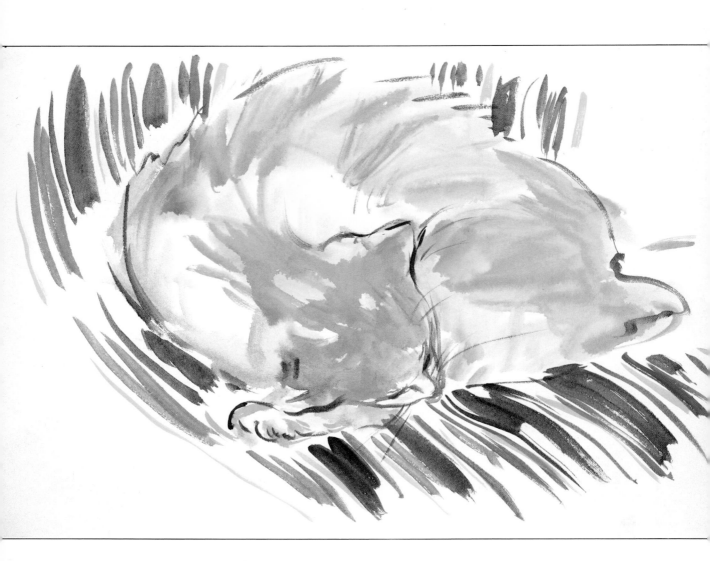

PAINTING WITH RAGS

There is no rule that says you have to paint with a brush. Fascinating and unexpected results can be achieved using less orthodox painting implements – sponges, rags, even a finger dipped in paint. Although for some people these methods of painting have connotations of primary school art lessons, they do have a valuable part to play in stimulating visual ideas. More importantly, they are an excellent way of loosening up and developing confidence with the watercolour medium.

This lively portrait of the artist's cat was painted literally in minutes using a piece of rag dipped in paint. The languid grace of a feline cries out to be captured in paint – but cats, being cats, are liable to yawn, stretch and walk away at just the wrong moment, so you have to work quickly. In a sense this can be an advantage, because it forces the artist to concentrate on the essential details and the finished painting has a rhythm and vitality which conveys a personal response to the subject.

Kay Gallwey
Mr Bill Asleep
38 x 58cm (15 x 23in)

USING RAGS

Working on a large sheet of paper with a rag dipped in watercolour paint and then wrapped around your finger or crumpled into a wad is a liberating experience. The fingers are sensitive tools, and because they are more or less in direct contact with the paper, you will find yourself working more boldly and intuitively, making fluid and decisive marks.

Irregular, mottled textures and patterns can be obtained by dabbing paint onto the paper with a sponge or a crumpled piece of rag. You can use this effect to paint weathered rocks, for example, or to give textural inter-est to an empty foreground. And by smearing the paint on you can create soft marks suitable for painting skies and water, flowers or animal fur.

Rags and sponges are also useful for the rapid application of paint over large areas and for the smooth blend-ing of tones and colours. As the fol-lowing project demonstrates, this facility can be used expressively in a line and wash painting. The texture and markings of the cat's fur are built up with paint smeared on with a rag, and then brush lines are used to define the form of the cat and to sug-gest the background.

Try using a crumpled rag to suggest natural textures such as summer foliage or weathered rocks. Dampen the rag and squeeze it into a ball. Dip it into a pool of colour, then press it gently onto the paper and lift it cleanly away. A natural sponge can be used in the same way.

MR BILL ASLEEP

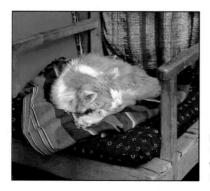

Left: The artist painted the cat from life, choosing an opportune moment when he was taking a nap after lunch.

Materials and Equipment

• SHEET OF 300GSM (140LB) HOT-PRESSED WATERCOLOUR PAPER, STRETCHED • WATERCOLOURS: CADMIUM ORANGE, CADMIUM YELLOW, CADMIUM RED, PAYNE'S GREY, IVORY BLACK, BURNT UMBER AND MAGENTA • COTTON RAG • FINELY TAPERED WATERCOLOUR BRUSH

1

Roughly wet the paper with a damp rag. Mix fluid washes of cadmium orange and cadmium yellow on your palette (a white plate is useful as you can use the central area for mixing the colours). Crumple a piece of cotton rag between your fingers, dip it into the cadmium orange wash and quickly draw the outline of the cat. Build up the colour and texture of the fur with pale tints of cadmium orange and cadmium yellow, smearing the paint on with the rag using broad marks that follow the form of the cat.

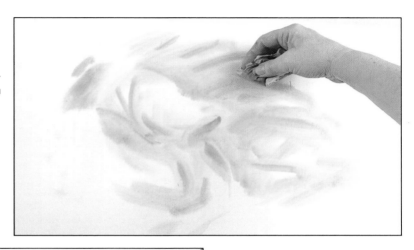

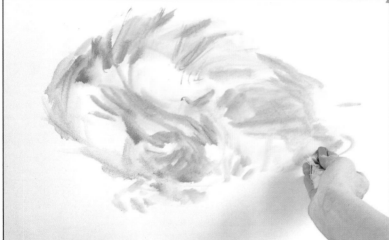

2

Using stronger colours now, continue to work up the form of the cat. Wrap the rag around your finger, dip it into the paint and make swift, gestural marks with it. The aim is to define the shape and posture of the cat, at the same time suggesting the texture and markings of the fur, so refer constantly to your subject. Vary the colour by adding touches of cadmium red to deepen it, particularly on the head, so as to bring it forward in the picture plane. Use soft, pale marks of Payne's grey for the shadow areas and to define the area of the eyes and nose.

3

Having established the underlying form, continue building up the ginger colour of the fur with stronger, deeper tones of cadmium orange mixed with cadmium red. Leave to dry. Paint the cushion with magenta, ivory black and cadmium yellow stripes. Finally, use a finely tapered brush to define the shape of the head and features with delicate lines of ivory black and burnt umber applied loosely and lightly.

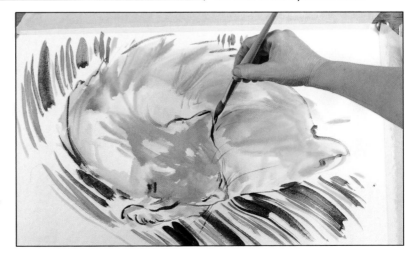

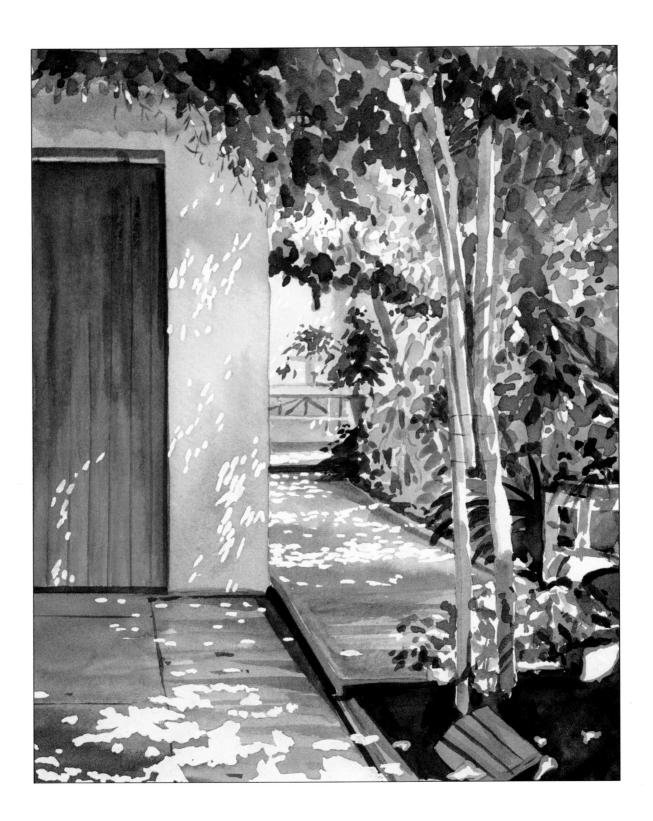

Masking Out

Because watercolour is transparent, it is impossible to paint a light colour over a dark one; you have to decide in advance where your white areas are going to be and then paint around them. Leaving small or detailed areas white can, however, be tricky because it inhibits the flow of the surrounding washes. The solution is to use masking fluid (liquid frisket) to seal off the white areas, allowing the rest of the surface to be painted over freely.

In this atmospheric courtyard scene, dappled sunlight filtering through the trees plays on every surface. The artist painted these highlights with masking fluid to preserve them and then laid the washes on top. When the painting was completed the masking fluid was removed to reveal the white "negative" shapes, which were modified by further pale washes to create an impression of warmth and sunlight.

Mark Topham
Summer Courtyard
28 x 22cm (11 x 8½in)

USING MASKING FLUID

Masking fluid (liquid frisket) is a dilute rubber solution. It is sold in bottles and is slightly tinted so that you can see where it has been applied. When brushed onto the paper it dries quickly to form a water-resistant film, protecting the area underneath while you finish the rest of the painting.

Simply brush the fluid over the areas which are to remain white. Once it is dry, you can ignore the white shapes completely and paint around them. When the painting is completely dry, remove the rubbery mask by rubbing gently with a fingertip, revealing the untouched paper beneath.

If you intend using masking fluid, choose a paper with a medium surface (known as Not or cold-pressed), from which the rubbery solution is easily removed; it is not suitable for use on rough papers as it sinks into the indentations and cannot be peeled off completely. On smooth (hot-pressed) papers the danger is that the surface will be spoiled by the action of rubbing away the mask.

Always use an old brush to apply masking fluid, and wash it in warm, soapy water immediately after use to prevent the fluid from drying hard on the bristles.

 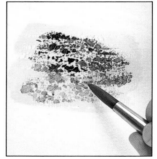

Masking fluid can be used to create weathered textures in a landscape painting. Here the fluid is applied and then partially rubbed away just before it dries.

When the mask is dry washes of colour are applied over the area; the mask resists the wash, but the colour sinks into the tiny patches which have been rubbed away.

When the paint is totally dry the mask is gently removed by rubbing with the fingertip. This reveals a mottled texture which could be used to suggest tree bark or old stone.

SUMMER COURTYARD

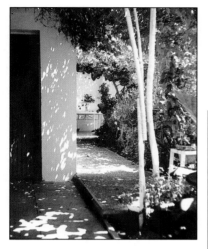

Left: While visiting friends, the artist painted this view of their patio garden. The confetti-like patterns of light falling through the trees and the vine-covered pergola made an attractive subject.

Materials and Equipment

- SHEET OF 300GSM (140LB) NOT (COLD-PRESSED) SURFACE WATERCOLOUR PAPER, STRETCHED • SOFT PENCIL • RULER • OLD WATERCOLOUR BRUSH FOR APPLYING MASKING FLUID (LIQUID FRISKET) • MASKING FLUID • WATERCOLOUR BRUSHES: LARGE AND MEDIUM-SIZED ROUNDS • WATERCOLOUR PAINTS: BURNT SIENNA, YELLOW OCHRE, SAP GREEN, AUREOLIN, FRENCH ULTRAMARINE, PAYNE'S GREY, VIRIDIAN • TISSUES

1

Start by making a careful line drawing of the subject, taking care that the lines are light enough not to show through the watercolours. Using an old paintbrush, paint masking fluid (liquid frisket) over those areas of the image which are to be left white. Wash the brush out immediately and leave the fluid to dry hard.

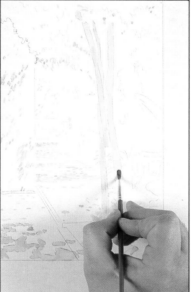

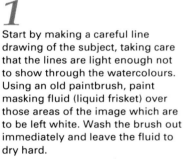

2

Apply clean water to the wall of the building on the left. When the shine has left the paper, paint the wall with a pale, variegated wash (see pages 74–79), starting with burnt sienna at the top, then yellow ochre, sap green, aureolin and finally ultramarine at the base. Use a large round brush and allow the colours to fuse wet-into-wet (see pages 66–73) on the paper.

3

Wash in the background area with a pale mixture of aureolin and a little sap green. While the paint is still damp, drop in a little yellow ochre here and there to indicate light-struck areas and ultramarine to indicate cool, shadowy areas.

4

Using the same colours as in step 3, but less dilute, paint the foliage with a medium-sized round brush. Use small, dabbing strokes and vary the tones of green from light to dark. Use mixtures of Payne's grey, burnt sienna and ultramarine for the dark foliage at the top left.

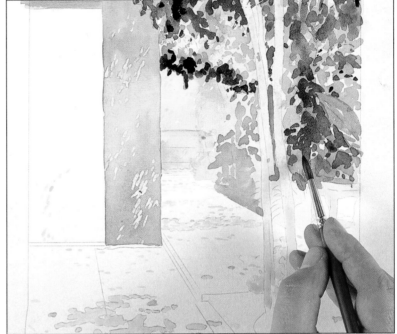

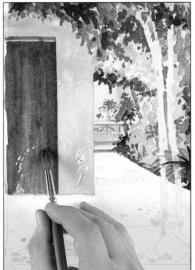

5

Paint the wooden door with a mixture of viridian and Payne's grey, lightening the tone with more water near the base. Add a spot of sap green at the bottom to give an impression of reflected light from the courtyard outside.

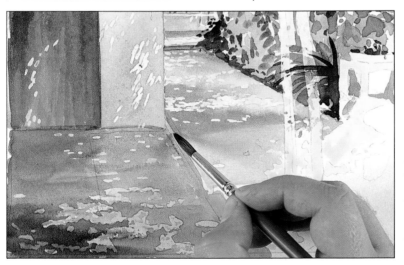

6

Paint the paving stones using various mixtures of Payne's grey, yellow ochre, burnt sienna, sap green and ultramarine. Keep the tones pale and light in the background, and stronger and darker in the foreground. This helps to create a sense of perspective and distance.

7

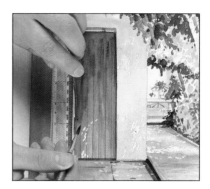

When the paint has dried, use a mixture of Payne's grey and burnt sienna and a finely pointed brush to indicate the wooden panels of the door. If you don't have a steady hand you may find a ruler useful here; bunch your fingers underneath the ruler so it doesn't touch the paper, then draw the brush along the ruler with the ferrule resting on its edge.

8

When the painting is thoroughly dry – and not until – remove all the masking fluid by rubbing gently with a fingertip; all the highlights are now revealed, perfectly preserved.

9

The masked areas appear rather stark, so warm them up with just a hint of colour. Mix aureolin and a touch of burnt sienna to a very pale tint and apply this to the patterns of dappled light, dabbing the colour off with a tissue if it looks too strong.

Add shadows to the white-painted support posts of the pergola on the right with a pale wash of ultramarine. This helps to recreate the warm, sunny atmosphere of the setting. Finally, paint the terracotta pot on the right with burnt sienna.

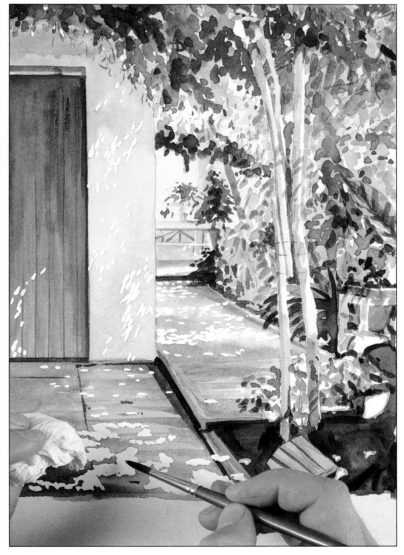

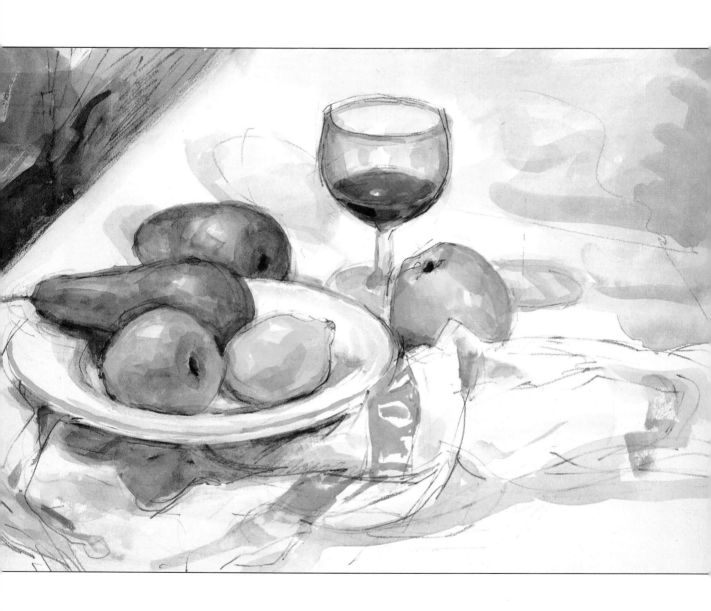

WORKING FROM LIGHT TO DARK

Working from light to dark is the classical method of building up a watercolour painting; the artist starts with the palest of washes and builds up the tones and colours very gradually to the density required. This structured method of using watercolour is sometimes called "wet-on-dry", and is especially useful for modelling the forms of objects to suggest volume.

In this informal still life the artist applies crisp strokes and washes of transparent colour, one on top of the other, to suggest the firm but rounded forms of the fruits.

~

Elizabeth Moore
Still Life
28 x 38cm (11 x 15in)

~

LIGHT TO DARK TECHNIQUE

Because watercolour is transparent, light colours cannot be painted over dark ones; the dark areas have to be built up gradually by overlaying colours in successive layers. Working on dry paper, the lightest tones are applied first and left to dry; then progressively darker tones are built up where required, leaving the lightest areas intact. This process results in richer, more resonant passages than can be achieved by painting with a single, flat wash of dense colour.

This technique requires a little patience, because it is essential to allow each layer of paint to dry before applying the next; if you do not, the colours will simply mix and the crispness and definition will be lost. To speed up the process, you can use a hairdryer on a cool-to-warm setting. Remember also that the characteristic freshness and delicacy of the medium is lost if too many washes are allowed to build up, so always test your colours on scrap paper before applying them to the painting; a few layers, applied with confidence, will be more successful than colours muddied by constant reworking.

This simple image demonstrates how to build up overlapping washes of colour from light to dark and create a convincing sense of three-dimensional form.

STILL LIFE

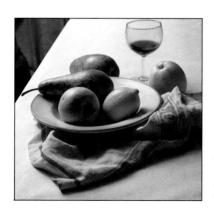

Left: A lamp was placed above and to the left of the still-life group; this powerful light source creates strong shadows that help to define the forms of the fruit.

Materials and Equipment

• SHEET OF 300GSM (140LB) HOT-PRESSED WATERCOLOUR PAPER, STRETCHED • SOFT PENCIL • KNEADED PUTTY ERASER • WATERCOLOUR BRUSH: MEDIUM-SIZED ROUND • WATERCOLOUR PAINTS: ALIZARIN CRIMSON, LEMON YELLOW, SAP GREEN, RAW UMBER, CADMIUM RED, PAYNE'S GREY

1

Make a light pencil drawing of the group. Begin with the lightest tones, keeping all your colours pale and transparent. Note where the brightest highlights are and indicate them by leaving the paper white.

Using a medium-sized round brush, paint the wine with alizarin crimson. Paint the lemon and the apple on the right with lemon yellow; the apple on the plate with sap green, and the pears with varied tones of raw umber and sap green. Indicate the bowl of the wine glass and the cast shadows on the cloth with Payne's grey. Paint the pattern on the cloth with cadmium red.

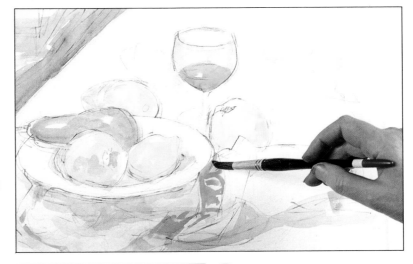

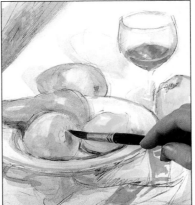

2

Prepare slightly stronger mixes of your colours and add the mid-tones, working around the highlights and paler tones. Add strokes of alizarin and cadmium red to the wine. For the pears, apply overlaid washes of raw umber and sap green, using curved strokes that convey the rounded forms of the fruits. Model the apples with strokes of sap green and lemon yellow, and strengthen the colour of the lemon with overlaid washes of lemon yellow. Paint the rim of the plate with sap green.

3

Continue developing the mid-tones and shadows, leaving the highlights intact. Add hints of pure colour here and there to add "zing". The subtle modulations of colour and tone are achieved by overlaying strokes of delicate, transparent pigment, like so many layers of tissue paper. Observe, too, how the brush strokes are left largely unblended to create textural interest.

Finally, darken and strengthen the tones in the wine glass, the fruits and the shadow beneath the plate.

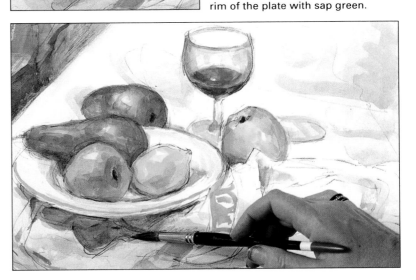

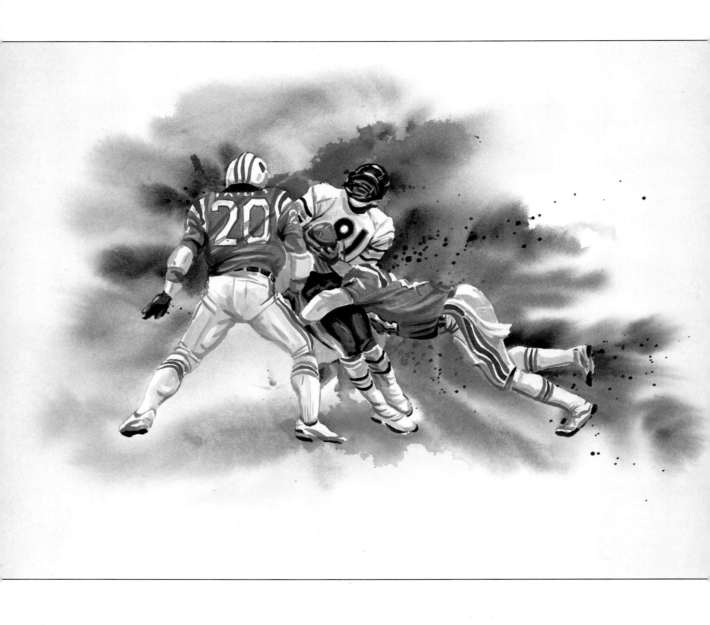

B O D Y C O L O U R

Portraying a moving subject is one of the greatest challenges facing an artist, and it is all too easy to end up with stilted figures and trees that look like cardboard cut-outs. But when it comes to capturing movement, a fluid medium like watercolour almost does the work for you; a watercolour wash, applied to wet paper, will spread, streak and blur of its own accord, and these expressive marks have an inherent energy of their own.

In this painting the artist exploits the physical contrast between thin and thick paint to capture the drama and fast pace of a game of American football. The strong, graphic qualities of gouache accentuate the bright colours and the sheer bulk of the heavily padded figures, while the streaks and blurs of watercolour in the background capture the momentum of the tackle.

~

Mark Topham
American Football
30 x 41cm (12 x 16in)

~

USING BODY COLOUR

The term "body colour" refers to opaque water-based paint such as gouache. The term is also applied when Chinese white watercolour paint, which is opaque, is used to add highlights in an otherwise transparent watercolour painting.

Some "purists" reject the idea of using body colour because it destroys the delicacy which is the hallmark of transparent watercolour. Yet many great artists, including Turner and Picasso, have mixed transparent washes with body colour to achieve particular effects. Watercolour and gouache are, after all, made up of the same basic ingredients, and they can work well together in the same painting, the opacity of gouache enhancing the transparency of watercolour.

If you have not used gouache paints before, it is a good idea to experiment with them before embarking on a painting. Gouache may be used thick, but still wet, or it can be thinned down so that it resembles pure watercolour. Unlike watercolour, it is possible to work from dark to light with gouache, adding white to lighten the colours rather than thinning them with more water.

The only disadvantage of gouache paints is that they remain soluble even when dry, which means that brushing a layer of wet paint over another layer tends to muddy the colours. However, this problem can be overcome by mixing acrylic glaze medium — available in tubes from art supply stores — into the paints. The acrylic glaze medium acts as a sealant, allowing you to build up successive washes without disturbing the layers beneath.

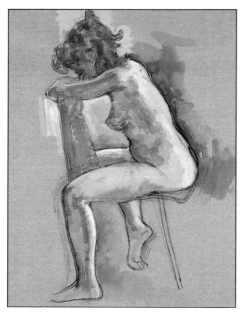

Body colour is particularly effective on tinted papers. In this nude study the buff paper forms the mid-tones, while the highlights on the figure's back and legs are accentuated by adding Chinese white to the transparent colours.

AMERICAN FOOTBALL

1

Make a careful outline drawing of the figures and the details of their clothing. Using an old paintbrush, fill in the shapes of the figures with masking fluid (liquid frisket) and leave to dry.

Materials and Equipment

• SHEET OF 300GSM (140LB) NOT (COLD-PRESSED) SURFACE WATERCOLOUR PAPER, STRETCHED • SOFT PENCIL • KNEADED PUTTY ERASER • OLD WATERCOLOUR BRUSH FOR APPLYING MASKING FLUID (LIQUID FRISKET) • MASKING FLUID • WATERCOLOUR BRUSHES: LARGE AND SMALL ROUNDS, MEDIUM-SIZED FLAT • WATERCOLOUR PAINTS: NEUTRAL TINT, INDIGO, ALIZARIN VIOLET, SAP GREEN AND FRENCH ULTRAMARINE • GOUACHE PAINTS: CADMIUM RED, HAVANNAH LAKE, SAP GREEN, ULTRAMARINE, BURNT SIENNA, GOLDEN YELLOW, YELLOW OCHRE AND ZINC WHITE • ACRYLIC GLAZE MEDIUM

2

Start by painting the background with transparent watercolour. On separate areas of your palette, mix dilute washes of neutral tint, indigo and alizarin violet watercolours. Using a large round brush, saturate the entire painting area with clean water.

When the shine has left the paper, paint the background around the figures with fast, spontaneous strokes of the three colours using a medium-sized flat brush. Let the colours merge wet-into-wet (see pages 66–73) where they meet, at the same time using the brush to guide the colours outwards from the figures so that they fade out into the background. Indicate the grass with sap green.

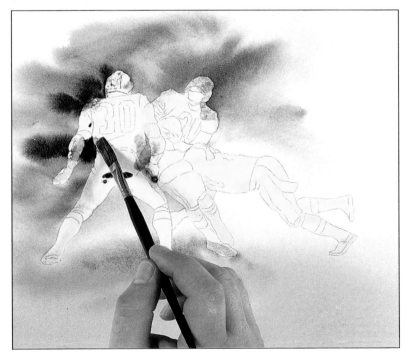

3

To emphasize the movement of the "flying" figure on the right, apply strokes of French ultramarine and neutral tint behind him, again allowing the colours to spread outwards. Leave to dry.

4

To give an impression of dirt being kicked up by the players' feet, use the spattering technique. Load the brush with a dark wash of neutral tint, then hold it at a shallow angle about 2.5cm (1in) above the paper. Gently tap the brush with a forefinger to release a shower of drops onto the paper. If necessary, use a hairdryer to dry the spattered area and prevent the colour from soaking into the paper.

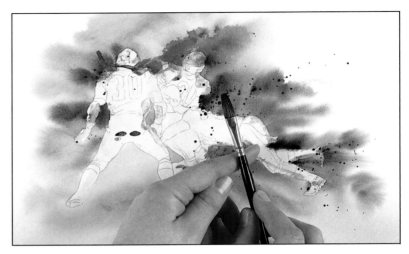

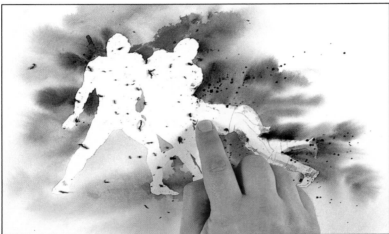

5

When the background is completely dry, remove the masking fluid from the figures by rubbing with a clean fingertip. You may have to reinstate the pencilled details on the clothes as they may have been rubbed away with the dried mask.

6

Then paint the figures using gouache, remembering to add a little acrylic glaze medium to the initial colours. Using a small round brush, paint the jerseys with cadmium red, darkened with a touch of Havannah lake in the shadow areas. Paint the green helmet and pants with sap green, darkened with ultramarine in the shadows.

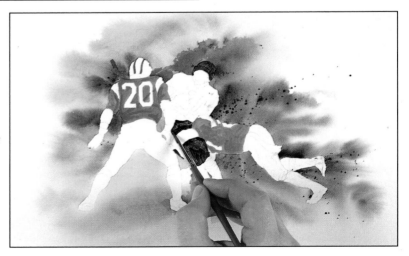

7

Using gouache, paint the football with a mix of burnt sienna and cadmium red, then paint the stripes and number on the central figure with golden yellow and sap green darkened with ultramarine. For the stripes on the other two figures, use cadmium red and ultramarine. Apply strokes of burnt sienna to the soles of the boots. Leave to dry.

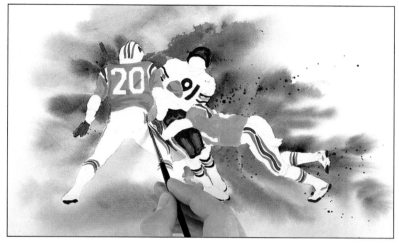

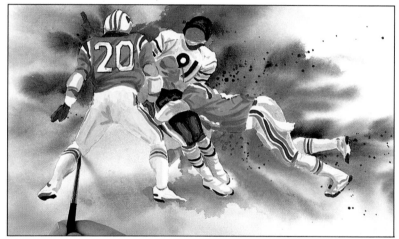

8

Block in the flesh tones of the figures using mixes of burnt umber, yellow ochre and zinc white. Use zinc white as the base for all the white parts of the players' clothing, mixing into it touches of alizarin violet watercolour, plus yellow ochre, ultramarine and cadmium red gouache for the shadows. It is these subtle hints of colour that help to describe the forms of the figures and create a sense of light.

Paint the folds and creases in the red jerseys using cadmium red darkened with ultramarine, and on the white jersey using neutral tint watercolour and zinc white.

9

Then all that remains is to paint the final details with fine brush strokes. Work all over the picture adding definition to the figures and clothing. For example, add more dark creases to the clothing and a few highlights with drybrush strokes (see pages 80–87) of zinc white. Paint the creases on the left-hand figure's pants with a mix of sap green and white gouache, and the highlights with pure white. Suggest the facial features on the central figure, then complete his helmet and visor.

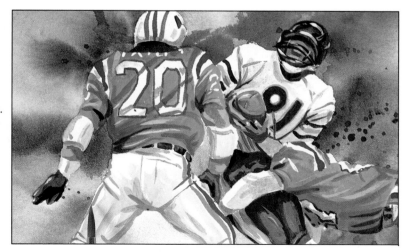

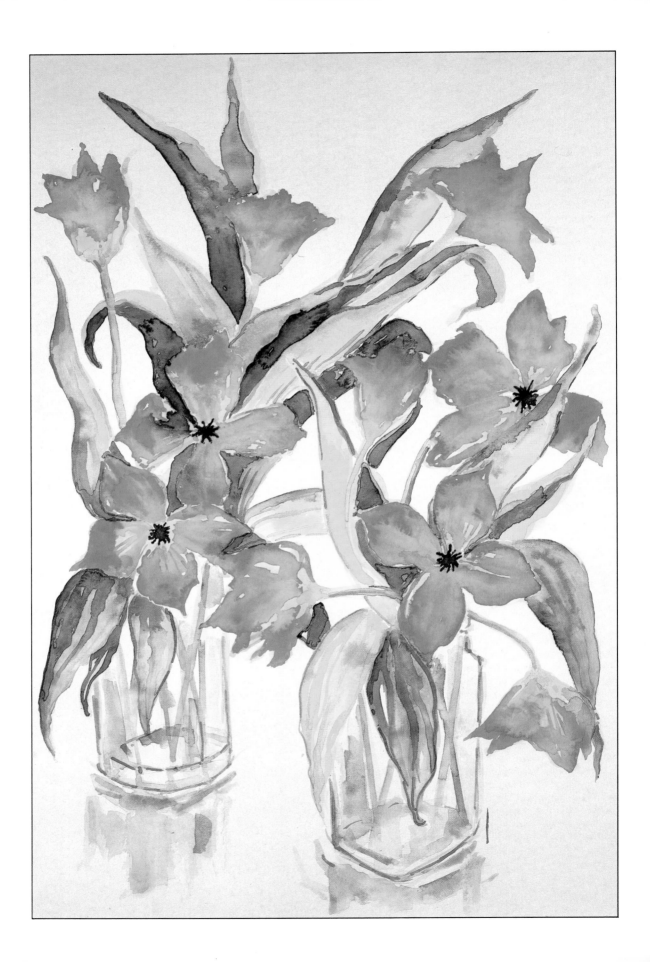

BACKRUNS

This painting was executed very quickly as the artist wanted to concentrate primarily on capturing the energetic shapes and gestures of the tulips and their foliage. In some areas wet washes were deliberately applied on top of still-damp ones to create marks and blotches known as "backruns", which not only add form and texture but also contribute to the spontaneity of the finished piece.

Some varieties of tulip make more appealing subjects to paint after they have been standing in water for a day or two, when the petals begin to open out and the leaves and stems bend and curl to form graceful shapes. The so-called "parrot" tulips are particularly interesting, with their frilled petals and vibrant striped markings.

Annie Wood
Parrot Tulips
74 x 53cm (29 x 21in)

USING BACKRUNS

Backruns, also known as "blooms", are those dreaded hard-edged blotches that sometimes appear in a water-colour wash just when you least want them. A backrun forms when one wash is flooded into another before the first wash has completely dried; as the second wash spreads out it dislodges some of the paint particles beneath, and these particles collect at the edge of the wash as it dries, creating a dark, irregular line.

Backruns can, however, be used quite deliberately to create textures and effects that are difficult to obtain using normal painting methods. For example, a series of small backruns creates a mottled pattern suggestive of weathered, lichen-covered stone; in landscapes, backruns can represent amorphous shapes such as distant hills, trees and clouds, or ripples on the surface of a stream; and they add texture and definition to the forms of leaves and flowers. Certainly part of the attraction of backruns is their power to suggest, encouraging the viewer to use their imagination.

It takes a little practice to create deliberate backruns (unwanted, accidental ones are much easier!). Backruns are more likely to occur on smooth papers than on absorbent or rough-textured papers.

Apply the first wash and allow it to dry a little. When the second is applied, the first should be damp rather than wet; if it is too wet, the washes will merge together without a backrun, as they do in the wet-into-wet technique (see pages 66–73). Small, circular backruns are formed by dropping paint from the end of a brush into the damp wash. Pale backruns can also be created by flooding or dropping clear water into a wash.

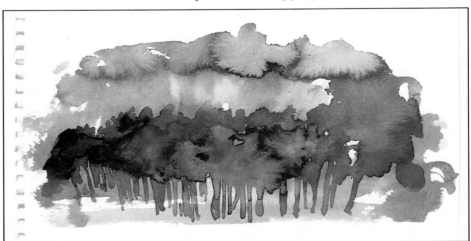

Here backruns have been deliberately created by dripping water into the wet paint; this pushes the pigment particles outwards, creating interesting mottled patterns suggestive of trees, clouds and swirling mist.

PARROT TULIPS

Materials and Equipment

• SHEET OF 410GSM (200LB) NOT (COLD-PRESSED) SURFACE WATERCOLOUR PAPER, STRETCHED • WATERCOLOUR BRUSHES: SMALL AND MEDIUM-SIZED ROUNDS • WATERCOLOUR PAINTS: LEMON YELLOW, SCARLET LAKE, CADMIUM YELLOW PALE, CHROME GREEN LIGHT, VIRIDIAN, CERULEAN, CARMINE AND ALIZARIN

1

Mix a large wash of lemon yellow and, using a small round brush, lightly draw the outlines of the flowers and the vases.

2

With a medium-sized round brush, fill in the shapes of the flowers (but not the leaves) with lemon yellow. As you work, go back to the flowers already painted and drop in some clean water from the end of the brush to keep the paint wet.

3

Mix cadmium yellow pale and a
touch of scarlet lake to make a pale
orange. Apply this colour to the base
of the petals and allow it to spread
a little.

4

Use a small round brush and gently
guide the orange pigment upwards
slightly, allowing the colour to fade
gradually into the wet underlayer of
yellow. At the same time, take the
colour around the outlines of the
petals to define them.

5

Fill in the leaf shapes with lemon
yellow, strengthened with cadmium
yellow pale in places. While the
paint is still wet, paint the mid-tones
in the leaves with chrome green
light. Lightly indicate the flower
stalks and the shadows in the clear
glass vases.

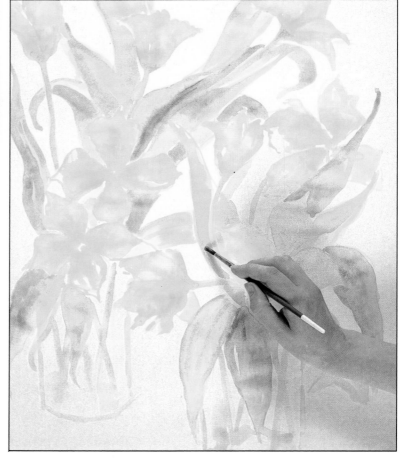

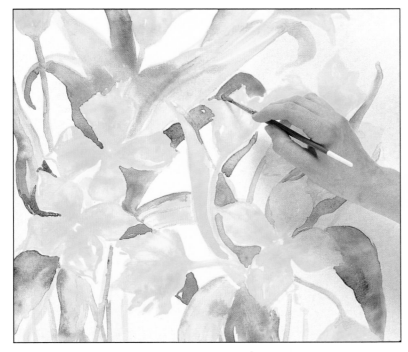

Above: In this detail you can see the effect of dropping wet paint into a semi-wet wash; the second colour seeps out into the first, creating little "blooms" and blotches that add interesting texture.

6
Allow the paint to dry a little, then paint the darker shadows and striping on the leaves with viridian.

7
Add definition to some of the details on the leaves with cerulean, this time using the paint a little more thickly. Use cerulean, diluted to a pale tint, to indicate the forms of the vases. Also indicate the reflections of the vases on the shiny surface of the table, gradually fading out the colour as you move downwards.

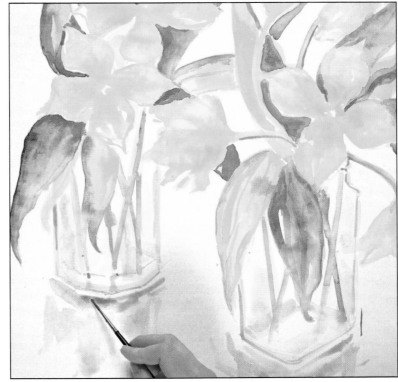

8

If the flower forms have dried, re-wet them and dab off any excess water with a tissue. Using a small brush, outline each petal with a fairly strong mix of carmine and then quickly guide the paint in from the edges and leave it to spread and diffuse of its own accord. Do not cover the yellow paint entirely, but paint the striped patterns on some of the flowers.

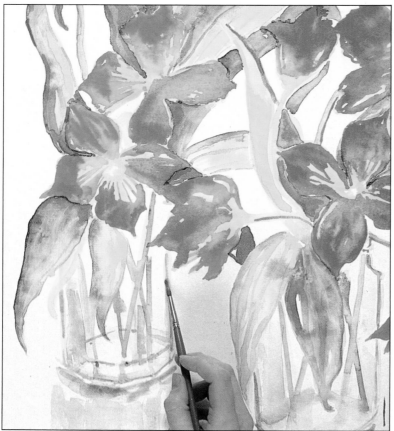

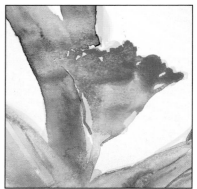

Above: This close-up detail shows the lovely gradations of colour that occur when the second colour bleeds into the wet paint beneath. Even if the colour runs back into the leaves in places, do not worry; it is "happy accidents" like these that lend poetry to a watercolour painting.

9

Continue painting the flowers, then add further detail to the vases and their reflections using carmine diluted to a pale tint.

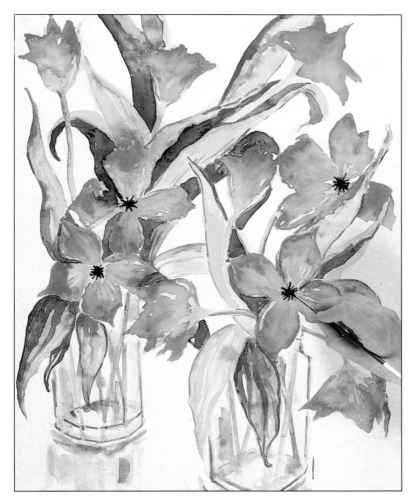

10

Using a strong mix of viridian, re-define the darks in the leaves. Then mix viridian and alizarin crimson to make a browny black and paint the stamens in the open flowers. Leave the painting to dry flat.

Right: This close-up of the tulip shows clearly how backruns can cre-ate textures and patterns which are particularly appropriate in flower painting. Here the hard edges of the backrun, at upper left, echo the deli-cately frilled edge of a petal.

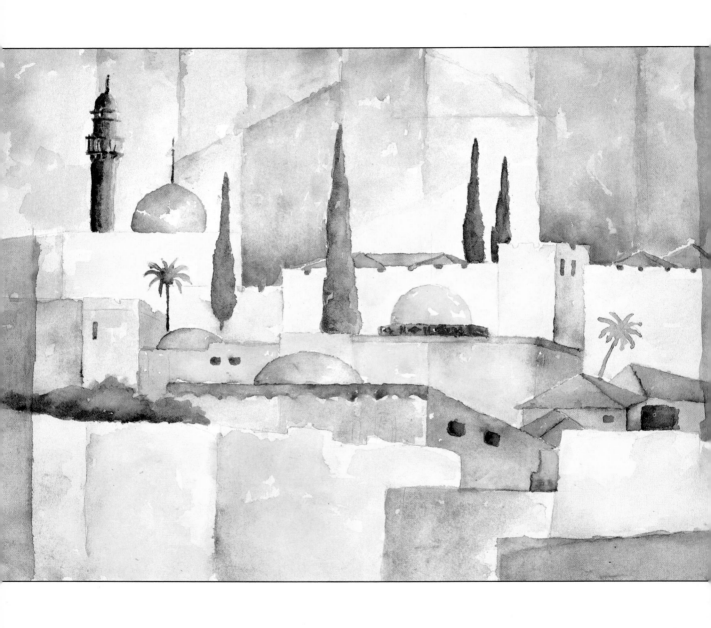

GLAZING

Glazing is a time-honoured technique usually associated with oil painting. The principle is to apply a thin transparent wash over another colour so that the underlying colour shows through. Glazed colours have an incredible richness and luminosity, seeming to glow from within.

In this semi-abstract painting, the artist has used coloured glazes to create fragmented planes of transparent colour that convey a lively impression of the architecture and strong sunlight of Jerusalem. The structural elements - the domes of mosques, flat-roofed buildings, palm trees, even the sky - are broken down into crystalline forms, creating a unified pattern of intersecting crescents and verticals.

~

Rivka Sinclair
Old Jerusalem
28 x 38cm (11 x 15in)

~

GLAZING TECHNIQUE

The chief characteristic of watercolour is its transparency, and in using the glazing technique this is exploited to the full. Glazing watercolours means applying the paints in dilute, transparent layers over one another, each layer being allowed to dry before the next is added, thus building up thin veils of colour. Because each layer is transparent, light is able to travel through to the white paper beneath and reflect back up through the colours. The result is rich and glowing, suggestive of the subtle and ephemeral qualities of light.

Glazing, otherwise known as the "wet-on-dry" method, is ideal for painting objects with precise shapes or hard, crisp edges. The dry surface "holds" the paint, so that brush strokes will not distort or "bleed".

It is interesting to experiment with glazing as a way of mixing colour. For example, try glazing a wash of blue over a dry wash of yellow to create green. Then mix the same two colours together on a palette and apply the colour to a sheet of paper; the glazed colour has a certain resonance and luminosity that the physically mixed colour lacks. This is because the incomplete fusion of the glazed colours produces a flickering optical sensation, so the surface of the picture seems to palpitate with light.

When glazing, always apply the palest colours first, so that light is allowed to reflect off the white paper. It is vital to allow one glaze to dry completely before applying the next, otherwise the clarity of the glaze is lost as the two colours will partially mix and become muddy. Remember, too, that dirty water will contaminate the colours, so change the water in the jar frequently, and rinse the brush thoroughly between colours.

Avoid applying more than two or three layers of colour when glazing in watercolour - any more and the delicate, transparent nature of the medium is lessened.

Glazing demonstrates the transparency and depth of watercolours. Try applying different-coloured glazes one on top of the other to create varied tones and hues.

OLD JERUSALEM

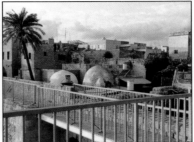

Above: This painting was done mainly from imagination and memory, with photographs of Jerusalem providing references for some of the details.

Materials and Equipment

• SHEET OF 300GSM (140LB) NOT (COLD-PRESSED) SURFACE WATERCOLOUR PAPER, STRETCHED • SOFT PENCIL • KNEADED PUTTY ERASER • WATERCOLOUR BRUSHES: 25MM (1IN) AND 13MM (½IN) FLATS, SMALL ROUND • WATERCOLOUR PAINTS: YELLOW OCHRE, NAPLES YELLOW, RAW UMBER, CHARCOAL GREY, FRENCH ULTRAMARINE, PURPLE, PAYNE'S GREY, ANTWERP BLUE, WINSOR BLUE, CERULEAN, BURNT SIENNA, WARM SEPIA, NEW GAMBOGE, RAW SIENNA, INDIGO, HOOKER'S GREEN NO.2, DARK GREEN, ALIZARIN CRIMSON, CADMIUM YELLOW

1

Draw the outlines of the subject using a soft pencil. Keep the lines light so that they will not show through the paint layers.

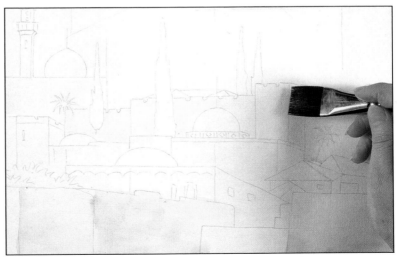

2

Mix yellow ochre and Naples yellow for the lighter walls of the buildings, and raw umber and charcoal grey for the darker walls. Use very pale tints of these colours so that the white of the paper shines through them. Hold the 25mm (1in) flat brush at a low angle to the paper and use the square end of the brush to block in the colours.

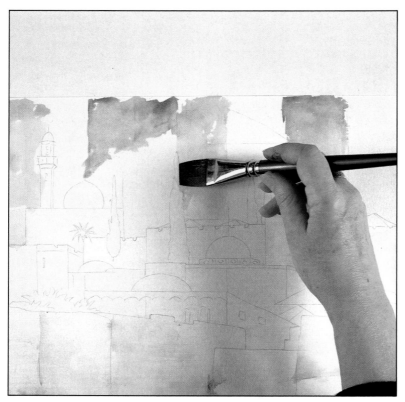

3

Mix a range of blues on a palette for the sky. Moving across from left to right, the artist has used the following mixtures: ultramarine, purple, Payne's grey and Antwerp blue; Winsor blue, cerulean and a touch of Payne's grey; cerulean and a touch of Payne's grey; and ultramarine, purple and a touch of Payne's grey. Apply the colours thinly, in separate "blocks" as shown.

4

With the smaller flat brush add further glazes of colour to the walls in the centre of the painting using various mixtures of burnt sienna, yellow ochre and warm sepia, still keeping the colour very diluted. Paint the blue domes with cerulean, purple and Payne's grey, leaving tiny flecks of white to indicate sunlight reflecting off them. Paint the rooftops using new gamboge and raw sienna, and burnt sienna and warm sepia. Paint the yellow dome with new gamboge and raw umber.

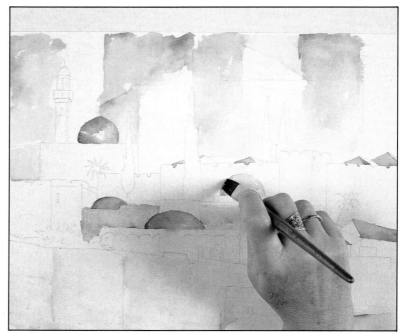

5

Mix ultramarine, purple and Payne's grey and fill in the darker areas of the sky, varying the intensity of the blue in each section so that they do not appear too uniform.

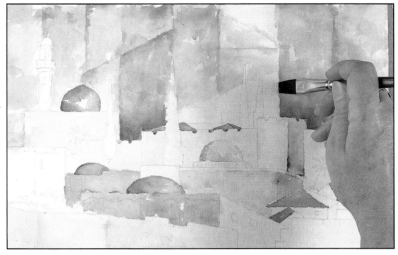

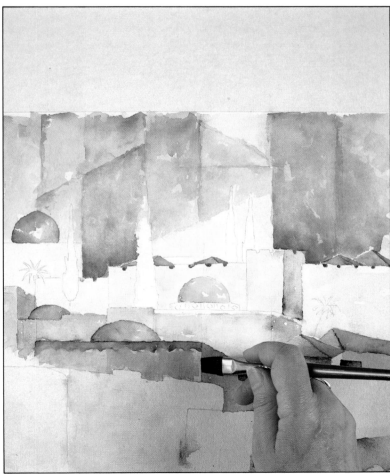

6

Paint the blue walls of the central building with purple, ultramarine and a hint of Payne's grey, strengthen the shadow side with indigo and ultramarine and use the same colour for the decoration along the top of the wall. Paint the other blue walls with similar blues.

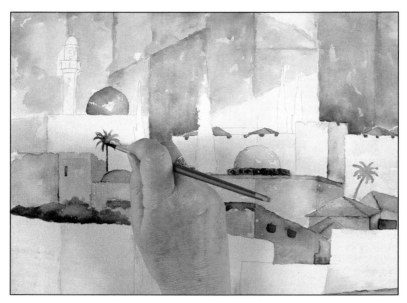

7

Using the small round brush paint the windows in the blue buildings with ultramarine and purple, and the decorative wall beneath the yellow dome with indigo and ultramarine. Paint the foliage on the left with Hooker's green no.2 and raw umber, darkened at the base with warm sepia. Paint the palm trees with a mixture of yellow ochre, Hooker's green no.2, dark green and alizarin crimson.

8

Paint the minaret with varied tones of cadmium yellow, raw umber and dark green. Observe here how the tones gradate from dark on the left to light on the right, indicating the rounded form of the tower. Mix a darker tone from raw umber and dark green and use the tip of the brush to lightly draw in the architectural features at the top of the minaret.

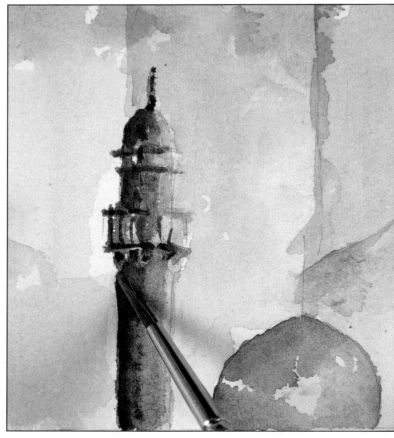

9

Paint the tall cypress trees with Hooker's green no.2 and yellow ochre, glazed over with Hooker's green no.2 and raw umber. For the cypress trees in the distance use dark green and cadmium yellow overlaid with dark green and raw umber. Strengthen the colours in the walls at the base of the picture with glazes of burnt sienna in some sections and ultramarine in others. Use a tissue to lighten any colours which look too strong.

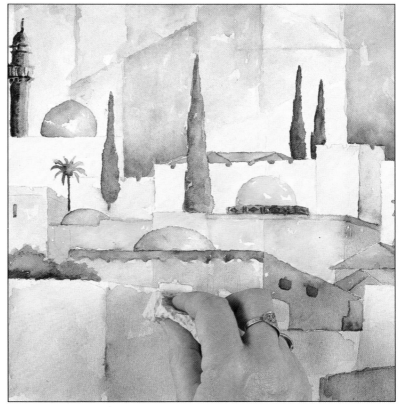

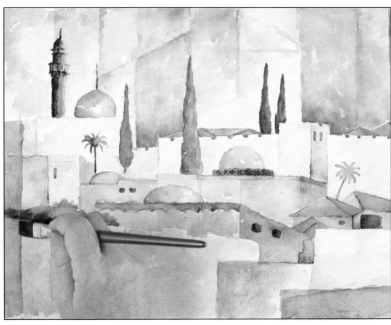

10

Paint the remaining windows with warm sepia and burnt sienna. Finally, mix a thin, transparent wash of indigo and ultramarine and apply broad, vertical strokes on the left and right sides of the painting.

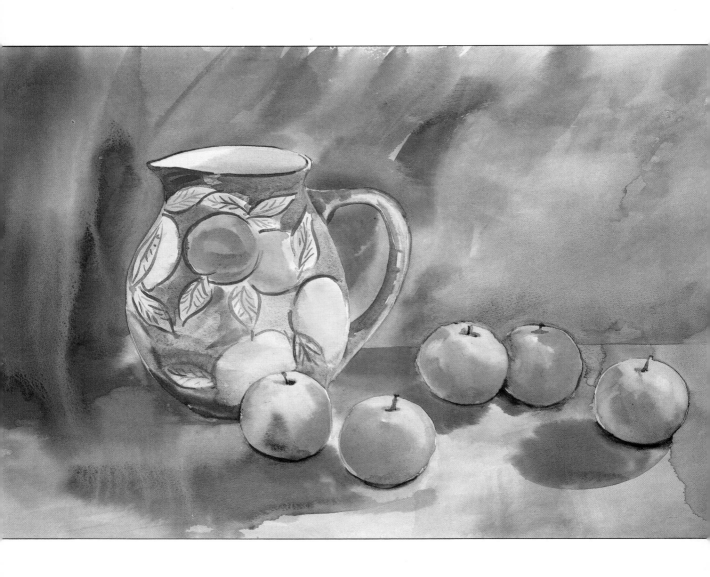

WET-INTO-WET

This still-life painting is a wonderful example of the interaction of water, paint and paper that is unique to the watercolour medium. The artist worked rapidly and intuitively, flooding the background colours onto wet paper and controlling the direction of the flow by tilting the board in different directions. The apples were painted while the background was still wet so as to create a slightly suffused effect. The result is more of a lyrical impression of the subject than a literal interpretation.

~

Penelope Anstice
Apples and Jug
38 x 56cm (15 x 22in)

~

WET-INTO-WET TECHNIQUE

Watercolour's reputation as a spontaneous, unpredictable medium is based largely on the effects produced by working wet-into-wet. In this technique, colours are applied over or into each other while they are still wet, so that they blend together softly with no hard edges. It is one of the most satisfying methods to work with, producing lively colour mixtures.

This technique is ideal for painting large expanses of soft colour, for example in skies and misty landscapes. When painting delicate or hazy subjects - flowers, fruits, shapes in the far distance - wet-into-wet allows the colours to blend naturally on the paper without leaving a hard edge.

For this technique it is best to use a heavy-grade paper (410gsm/200lb or over) which will bear up to frequent applications of water without warping. Lighter papers will need to be stretched and taped to the board (see pages 18–19). Moisten the paper with clean water using a large brush or soft sponge. Blot off any excess water with a tissue so that the paper is evenly damp, with no pools of water lying on the surface. This technique is not for the faint-hearted; you must work quickly and confidently, charging the colours onto the paper and allowing them to spread and diffuse of their own accord. Wet-into-wet is only partially controllable - that is part of the excitement - but you can tilt the board to direct the flow of the colours and create interesting patterns of diffusion. Keep a tissue handy for mopping up any colour where you don't want it.

A common mistake when working wet-into-wet is to dilute the paint too much, with the result that the finished painting is weak and insipid. Because the paper is already wet you can use quite rich paint - it will soften on the paper but retain its richness. You must also compensate for the fact that the colour will dry much lighter than it appears when wet.

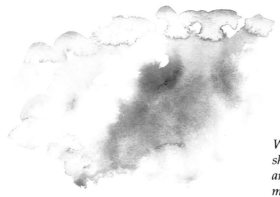

Wet-into-wet washes create soft, diffused shapes which perfectly capture the amorphous nature of cloud formations, mist and rain.

APPLES AND JUG

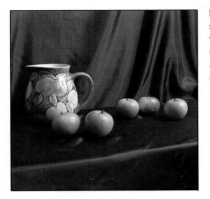

Left: This group was kept very simple so as to give the artist the freedom to apply broad washes of colour without having to work around awkward shapes. This simplicity is underlined by the restricted colour scheme of blues, reds and yellows.

Materials and Equipment
• SHEET OF 640GSM (300LB) NOT (COLD-PRESSED) SURFACE WATERCOLOUR PAPER, STRETCHED • SOFT PENCIL • KNEADED PUTTY ERASER • WATERCOLOUR BRUSHES: 25MM (1IN) FLAT, LARGE AND SMALL ROUNDS • WATERCOLOUR PAINTS: PRUSSIAN BLUE, MAGENTA, CADMIUM YELLOW PALE, NAPLES YELLOW, ALIZARIN CRIMSON, WINSOR GREEN, FRENCH ULTRAMARINE, VERMILION, YELLOW OCHRE, PAYNE'S GREY AND BURNT UMBER • TISSUES

1
Make a light outline sketch of the jug and apples and indicate the pattern on the jug.

2
Using a large flat brush, wet the paper with clean water, working around the shapes of the jug and apples. Prepare a diluted wash of Prussian blue mixed with a little magenta and apply this all over the wet area; apply the paint loosely, varying the direction of the brush strokes to create a lively effect.

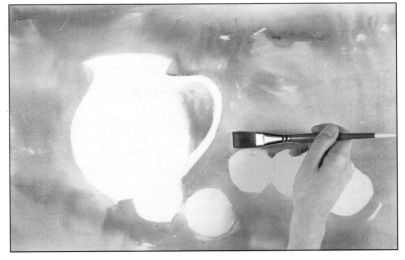

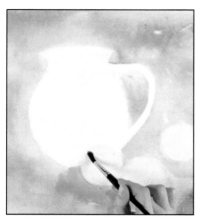

3

While the background is still damp, use a large round brush to paint the apples with a pale wash of cadmium yellow pale and a little Naples yellow.

4

Paint the pattern on the jug, again with pale washes; first fill in each shape with water, then drop in the colours - alizarin crimson for the plums, cadmium yellow pale for the lemon, and adding Winsor green to the latter for the leaves. Allow the colours to spread and soften on the paper.

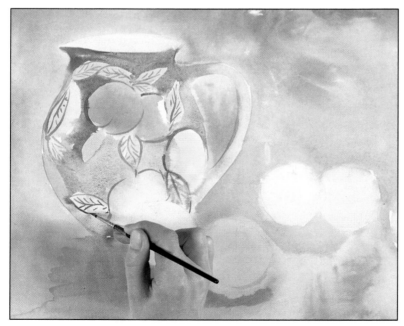

5

Fill in the background colour of the jug with diluted French ultramarine. With a small, well-pointed round brush, paint the outlines of the leaves and fruit with a darker mix of ultramarine.

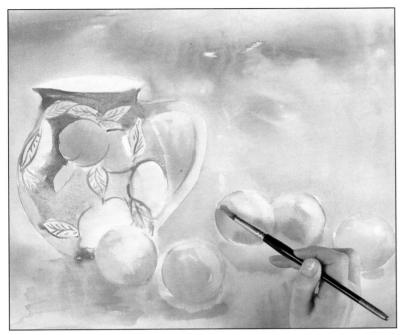

6

Exploit the wet-into-wet method to depict the apples (except for the one on the extreme right) with a variety of reds and greens. For the reds, use various mixtures of alizarin crimson, vermilion and yellow ochre; for the greens, a pale wash of cadmium yellow pale with a touch of Prussian blue. Moisten each apple with clean water, then apply the colours and allow them to fuse slightly. This gradual merging of the two colours creates a natural-looking, rounded contour.

7

Make sure the background wash is completely dry. Mix a large wash of Prussian blue and magenta, this time slightly stronger than the first wash. Re-wet the background with clear water, then apply the paint with broad, loose strokes, leaving patches of the undertone showing through in places. Use a smaller brush to apply colour in the gaps between the apples.

Tilt the board in various directions to encourage the paint to move around and do interesting things; for example, where wet paint flows back into damp paint, it will dry with a hard edge which adds texture and interest to the large expanse of background area. Leave to dry.

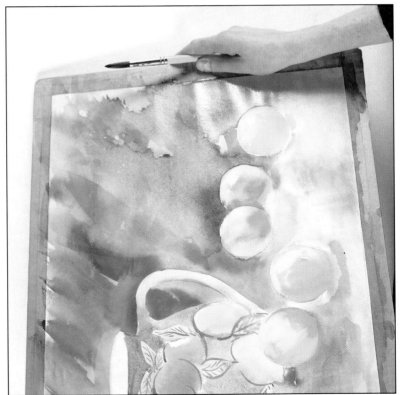

8

Wet the left half of the background and apply a third wash of Prussian blue and magenta, this time much darker than before. Use the same colour to paint the shadows on the table; first wet the shadow shapes, then fill them with paint and allow the paint to bleed softly into the surrounding areas, but use the brush to guide the paint away from the edges of the apples to keep them crisply defined. To anchor the apples to the table, darken the shadows directly beneath them with a touch of Payne's grey.

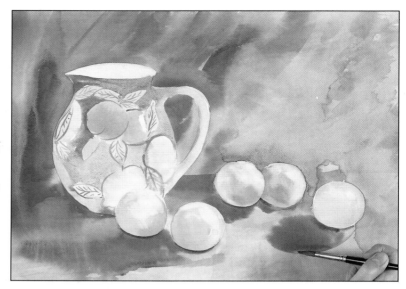

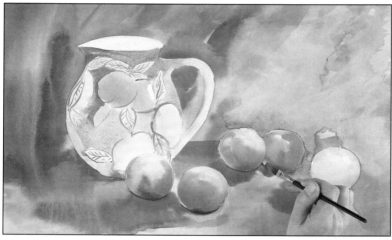

9

Mix yellow ochre and Prussian blue and apply this to the darkest areas of the apples while they are still wet, allowing the colour to merge into the red and green.

10

Paint the deeper shade on the russety apple on the right with the same colour used in step 9, then apply a stroke of alizarin crimson near the left edge and allow the colours to merge.

11

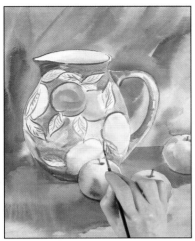

Paint the apple stalks with burnt umber and Payne's grey. Paint the darker tones on the jug and its handle with a deeper shade of ultramarine. Wet the shadow shape inside the jug and apply a wash of Naples yellow, darkened with a touch of ultramarine at the base of the shadow. Deepen the colours on the jug's pattern with further washes of the same colours used in step 4. Leave to dry, then use a strong tone of ultramarine and a small round brush to define the rim of the jug and sharpen the linear details on the jug's pattern.

12

Finally, re-wet the right-hand side of the background and, using a large flat brush, apply a loose wash of diluted alizarin crimson and magenta.

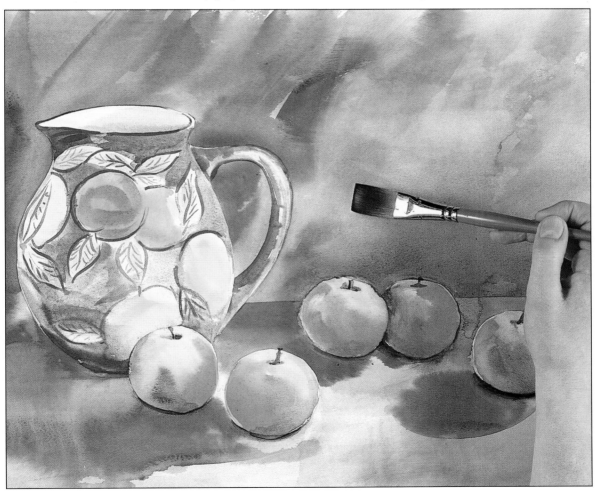

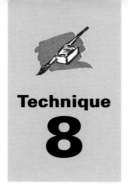

VARIEGATED WASHES

This attractive picture was painted on-the-spot in Goa, India. It relies for its effect on the way each colour blends softly into the next with no hard edges, evoking the steamy atmosphere of a tropical landscape after a monsoon rainstorm. Working on well-dampened paper, the artist applied strokes of variegated colour to the sky and landscape areas and allowed them to spread and diffuse to create the effect of the watery sky and the flooded fields. A heavy stretched paper with a Not (cold-pressed) surface, which would not buckle when heavy washes were applied, was used.

~

Penelope Anstice
Indian Landscape
28 x 38cm (11 x 15in)

~

USING VARIEGATED WASHES

In watercolour, exciting and unpredictable effects can be obtained with variegated washes - laying different coloured washes side by side so that they bleed gently into each other where they meet. Variegated washes need to be applied quickly and confidently, so it is advisable to mix the colours in advance.

Working with your board at a slight angle, paint a strip of colour onto well-dampened paper. Rinse the brush, then take a second colour and quickly lay it next to the first. Repeat this process with any subsequent colours. The colours will spread and diffuse on the damp paper and the edges will melt softly into each other. Resist the temptation to push the paint around too much once the wash has been laid as you risk spoiling the soft, delicate effect. Leave the wash to dry at the same tilted angle.

When working on damp paper you will need to mix your colours slightly stronger than you think is necessary. This is because the pigments spread and mix with the water on the paper surface, and will dry to a lighter shade than when first applied.

Variegated washes are often used in painting skies and landscapes, when soft transitions from one tone or colour to another are required.

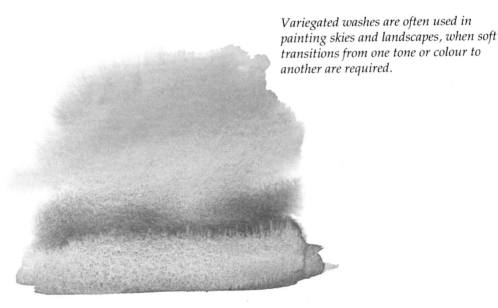

INDIAN LANDSCAPE

1
Lightly sketch in the main elements of the composition with a soft pencil.

Materials and Equipment
• SHEET OF 410GSM (200LB) NOT (COLD-PRESSED) SURFACE WATERCOLOUR PAPER, STRETCHED • SOFT PENCIL • KNEADED PUTTY ERASER • LARGE BRUSH OR SOFT SPONGE • WATERCOLOUR BRUSHES: MEDIUM-SIZED AND SMALL ROUNDS • WATERCOLOUR PAINTS: MAGENTA, NAPLES YELLOW, CADMIUM YELLOW PALE, FRENCH ULTRAMARINE, YELLOW OCHRE, CERULEAN, EMERALD GREEN, INDIAN RED, VIRIDIAN

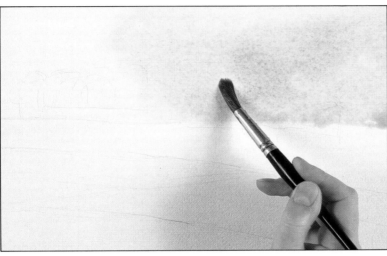

2
Wet the entire picture surface with clean water using a large brush or soft sponge. On the right of the picture, just above the horizon, drop in a mixture of magenta and a hint of Naples yellow. Either side of it, add a mix of Naples yellow and a touch of cadmium yellow pale. Allow the colours to bleed into each other where they meet.

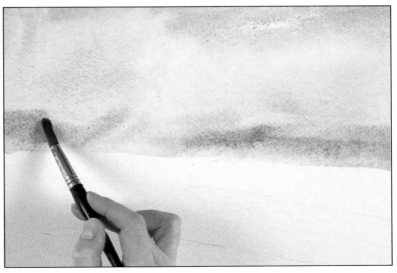

3
Complete the sky area by sweeping in a pale wash of ultramarine mixed with a touch of yellow ochre to temper the blue. Work quickly and loosely, varying the tones of blue so that the sky is not too flat. Mix a darker blue from cerulean and a hint of yellow ochre and apply this along the horizon to provide a background wash for the misty trees. This wash will blend into the sky colour leaving a soft edge.

4

Then indicate the marshy fields. Using a medium-sized round brush, sweep a few broad strokes of clean water across the lower half of the picture, leaving tiny slivers of dry paper between the strokes. Mix the following paints on the palette: yellow ochre and Naples yellow; emerald green and cadmium yellow pale; and ultramarine, magenta and Naples yellow. Sweep these three mixes into the wet brush strokes, allowing them to blend and fuse slightly where they meet. Leave to dry completely.

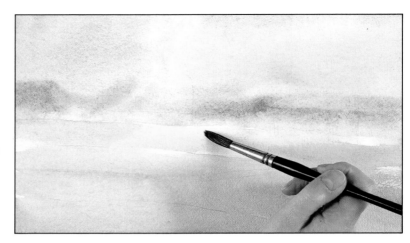

5

Paint the palm trees on the right with a pale tint of magenta and ultramarine. Re-wet the area of the main clump of trees and drop into it a mixture of magenta, ultramarine and yellow ochre. Allow the colours to blend partially.

6

Strengthen the colours in the fields using greys mixed from magenta, ultramarine and Naples yellow, and an earth colour mixed from Indian red and yellow ochre in the immediate foreground. Mix a purplish brown from cerulean, Indian red and yellow ochre and use a small round brush to add a few drybrushed lines (see pages 80–87) to add texture. Observe how the slivers of white paper between the strokes look like pools of water lying on the surface of the fields.

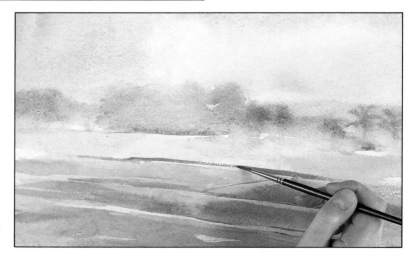

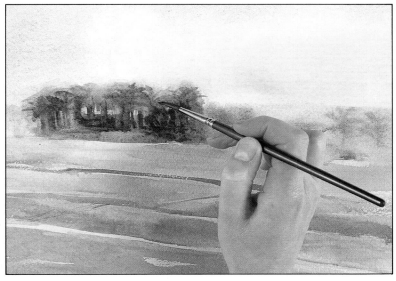

7

Re-wet the main clump of trees and work into it using a small round brush and cerulean, Indian red and yellow ochre. Paint the darker trunks and foliage of the trees with mixtures of viridian, ultramarine and cerulean, but don't overstate them - keep the forms soft and amorphous, otherwise you will lose the impression of mistiness.

Left: This detail shows how the forms of the trees are softened by lifting out some of the colour using a wet brush.

8

Finally, use a medium-sized round brush and a pale grey mixed from ultramarine and yellow ochre to paint the dark rain cloud near the top of the picture. Leave the painting to dry flat.

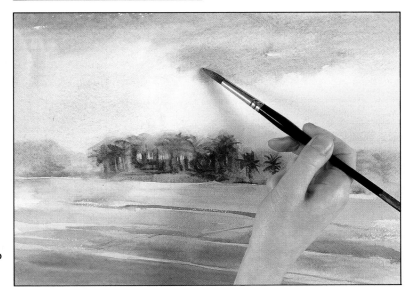

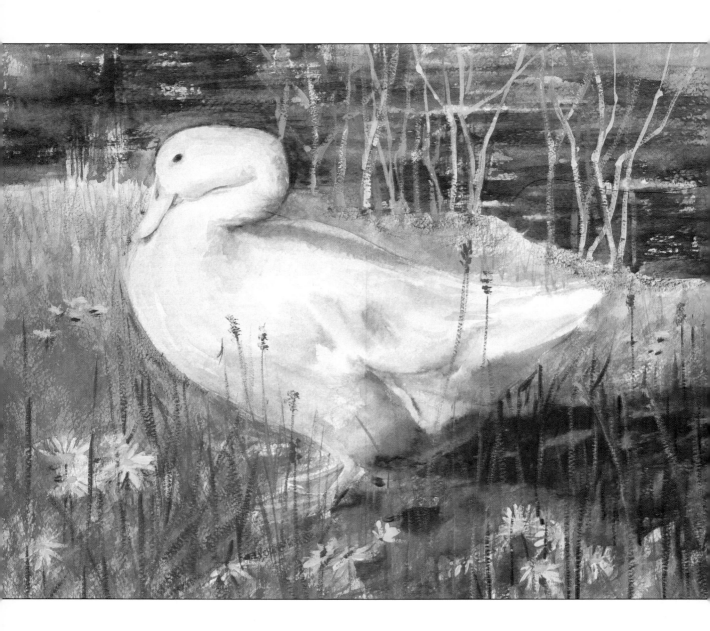

Technique

9

DRYBRUSH PAINTING

Quick, and decisive brush strokes are a key element in watercolour painting. The more that watercolour is manipulated, the more likely it is that the sparkle and spontaneity will be lost. This is where the drybrush technique is invaluable, because it can suggest meticulous detail and texture without the painting appearing overworked.

Drybrush is a highly expressive and versatile technique, particularly in landscape painting. It can be used to suggest anything from broken cloud to the sparkle of sunlight on water, the rough texture of rocks and tree bark, and the movement of trees and grass blowing in the wind.

In this painting there is an interesting contrast between the smooth, delicate washes of colour used to suggest the soft plumage of the white duck, and the loose, drybrushed texture of the grass.

~

Penelope Anstice
White Duck
36 x 56cm (14 x 22in)

~

DRYBRUSH TECHNIQUE

Drybrushing in watercolour produces soft-edged lines of fascinating irregularity in contrast to the smooth washes often associated with the medium. To produce a drybrush stroke, moisten the brush with very little water and pick up a small amount of paint on the tips of the bristles. Flick the brush lightly across a rag or paper tissue to remove any excess moisture, then skim the brush lightly and quickly over a dry painting surface.

This technique works best on a rough or medium-rough paper. The surface of a good-quality rough paper has a definite "tooth" and when a colour wash is laid sparingly over the top, some of the pigment gets trapped in the hollows and some adheres to the peaks. This leaves tiny dots of white which cause the wash to sparkle with light. Drybrush strokes have a ragged quality that is ideal for suggesting natural textures such as weathered rocks and wood, tree bark, grass and clusters of foliage.

The drybrush technique allows you to give an impression of detail and texture with minimal brushwork, thus avoiding the pitfalls of a clumsy, overworked painting. When painting water, for example, a deft stroke of dry colour that leaves tiny dots of white paper showing through can suggest the sparkle of sunlight on the surface. This quality is particularly useful in watercolour painting, which relies on freshness and simplicity of execution for its effect.

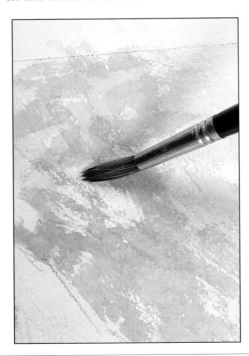

Drybrushing one colour or tone over another produces lyrical passages of colour with an almost three-dimensional quality. The tiny specks of untouched white paper sparkle through and enhance the translucent effect.

WHITE DUCK

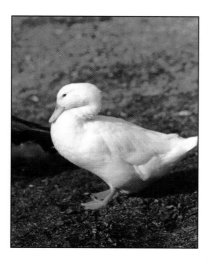

Left: Ducks and geese are a favourite subject for this artist. This painting was done largely from memory, with the aid of a photograph.

Materials and Equipment
• SHEET OF 300GSM (140LB) ROUGH SURFACE WATERCOLOUR PAPER, STRETCHED • SOFT PENCIL • KNEADED PUTTY ERASER • WATERCOLOUR BRUSHES: LARGE AND SMALL ROUNDS, 13MM (½IN) FLAT • WATERCOLOUR PAINTS: EMERALD GREEN, CERULEAN, CADMIUM YELLOW PALE, FRENCH ULTRAMARINE, BURNT UMBER, VERMILION, YELLOW OCHRE, NAPLES YELLOW AND CHINESE WHITE • TISSUES

1

With a soft pencil lightly sketch the shape of the duck and indicate the trees in the background.

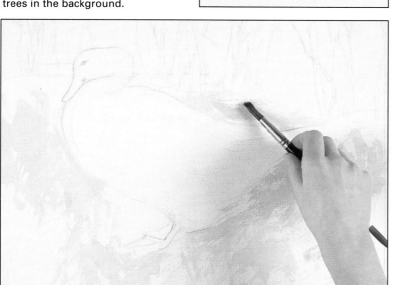

2

Mix emerald green with a little cerulean and cadmium yellow pale and mix with lots of water to make a pale tint. Working on dry paper, and with a fairly dry, large round brush, lightly scrub the colour over the area around the duck. These drybrushed strokes of cool colour will shine up through the subsequent paint layers, creating a lively colour effect.

3

When the first colour is completely dry, mix cadmium yellow pale and a touch of cerulean to make a warmer, lighter green, again diluted to a pale tint. Scrub the colour on as before, overlaying the cooler green beneath.

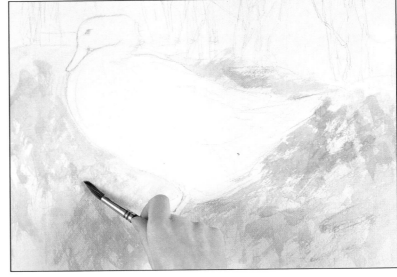

4

Mix emerald green and a touch of French ultramarine and indicate a few daisies in the foreground grass using a small, well-pointed round brush.

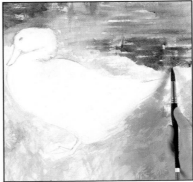

5

Using a large round brush, apply a few strokes of clean water to the stream in the background. Brush in a pale mixture of burnt umber, ultramarine and a touch of vermilion. Apply the colour with rapid horizontal strokes, allowing some strokes to spread on the wet paper. Lightly skim the surface of the paper so as to leave little flecks of white paper here and there that indicate the sparkle of the water. Leave to dry.

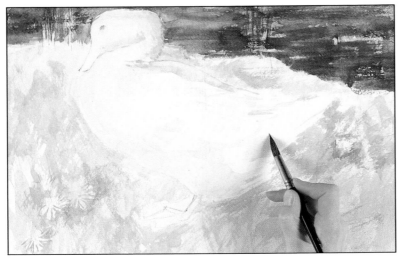

6

Darken the wash with more burnt umber and ultramarine and add further horizontal strokes to the stream, working carefully around the duck's head.

Mix a pale wash of ultramarine with a touch of cerulean and begin painting the cool shadows on the duck's head and body.

7

Paint the duck's feet with a pale wash of cadmium yellow pale and vermilion, darkening the back foot with a touch of ultramarine to push it back in space. Allow to dry, then add a second wash of colour except on the bones of the feet.

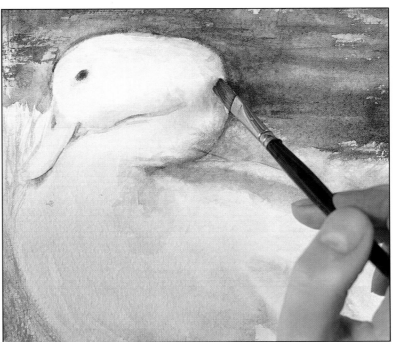

8

For the duck's beak use Naples yellow and a hint of vermilion, lifting out some of the colour with a tissue to create the highlight. Paint the shadow under the beak with the same mix, darkened slightly with ultramarine. With a small round brush wet the eye area with water and then add a drop of burnt umber and ultramarine in the centre and work the colour out towards the edges. This prevents the eye from appearing too hard and unnatural. Do the same with the breathing hole in the beak. Using the flat brush, model the form of the head with pale shadows mixed from ultramarine and yellow ochre.

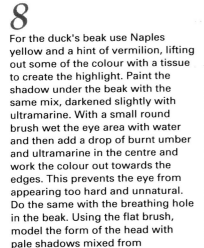

9

Introduce some colour variation in the grass with further drybrush strokes using varied mixtures of ultramarine and cadmium yellow pale, with hints of very pale vermilion here and there. Use the tip of the brush to paint some tall, spiky grasses in the foreground with a darker shade of green.

DRYBRUSH PAINTING

10

Continue painting the subtle
shadows and highlights on the
plumage with the large round brush.
For the cool shadows on the back
and wing use ultramarine and
yellow ochre diluted to a pale tint;
use the same colour, but stronger,
for the dark shadow under the tail.
The duck's breast reflects light from
the sun, so paint this area with
Naples yellow varied with yellow
ochre. Leave to dry.

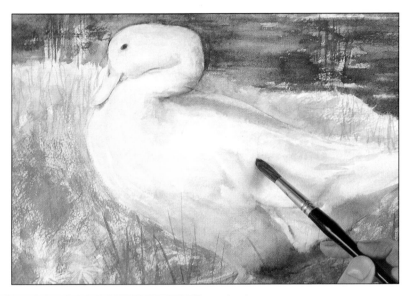

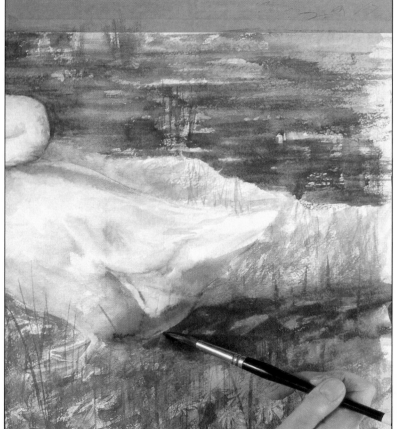

11

Mix a dark wash of ultramarine and
cadmium yellow pale, warmed with
a little vermilion, and paint the
shadow cast by the duck on the
grass. Apply the pigment loosely
and quite dry, not as a solid block
of colour.

12

With a wash of cadmium yellow pale
and a touch of emerald green, add
some warm hints of sunlight to the
grass, again with a dry flat brush.

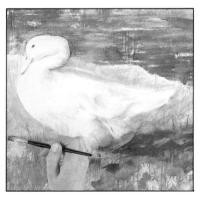

DRYBRUSH PAINTING

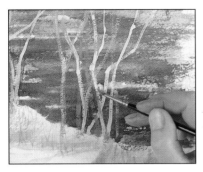

13

Paint the saplings at the edge of the water with Chinese white overlaid with a pale brown mixed from yellow ochre and Naples yellow. The paint should be quite thick, and applied very lightly with a dry small round brush so that it catches on the "tooth" of the paper and creates broken strokes that simulate the pattern of the bark.

14

With the same brush, paint the white daisies with Chinese white, and the yellow ones with a mix of cadmium yellow pale and white.

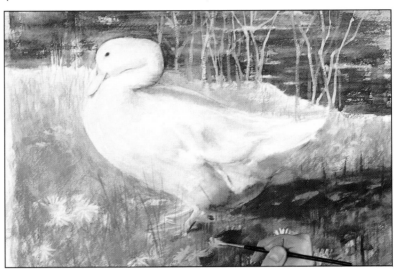

15

Paint the centres of the white daisies with cadmium yellow pale. Mix a dark green from ultramarine and Naples yellow and, with a dry flat brush, paint some tall grasses in the foreground. Use the same colour and a small round brush to paint the centres of the yellow daisies. Finally, lightly stroke in a few lighter grasses with a mix of Naples yellow and chinese white.

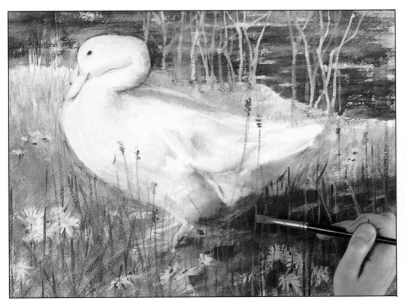

Below: This detail from the bottom left of the painting demonstrates the beauty and expressiveness of different-coloured drybrush strokes applied one on top of the other.

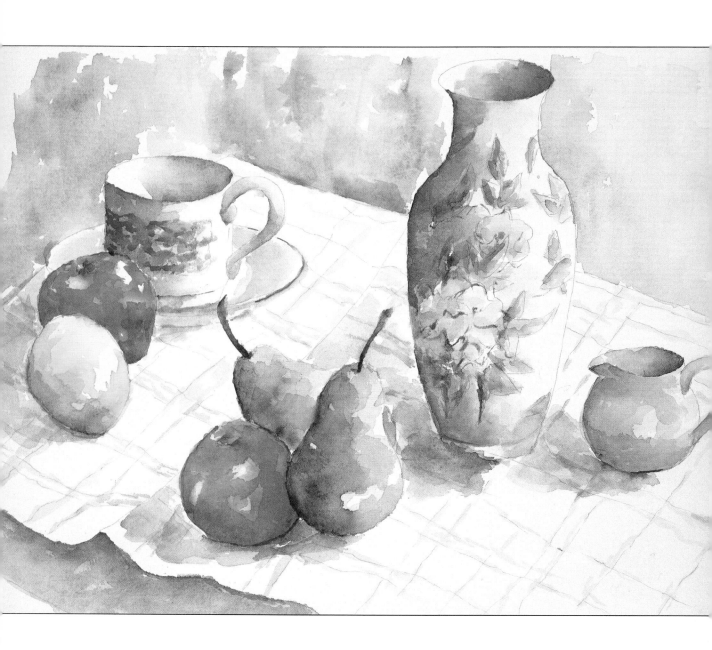

RESERVING WHITE AREAS

The essence of a good watercolour is freshness and spontaneity, and this results from knowing what to leave out of a painting, as well as how much to put in. Inexperienced painters often make the mistake of filling every inch of the paper with colour: in fact, with watercolour painting this is neither necessary nor desirable.

Think of the white of the paper as being another element in your palette of colours. Watercolour paper provides a unique, translucent white not available in any other medium, so use it to good effect when planning your paintings.

In this still-life painting the white of the paper is left untouched to suggest the smooth, shiny surfaces of the fruit and the china objects. The whole picture dances with light because the washes are broken up with little flecks of white paper - in the background, for instance. These white areas allow the painting to "breathe", and enhance the delicate nature of the subject.

~

Rivka Sinclair
Still Life with Fruit
28 x 38cm (11 x 15in)

~

CREATING HIGHLIGHTS

Because you cannot add a light colour over a dark one in watercolour, you must first decide where the brightest highlights are to be and paint around them. In this way you preserve the white of the paper, with its brilliant, light-reflecting properties; the highlights really "sing out" when the surrounding washes have been added. Of course, you will have to plan your painting carefully before you begin, so that you know where the highlights are to be.

When you paint around an area to be reserved for a highlight, it will dry with a crisp, hard edge. If you want a softer edge you can blend it into the white area with a damp brush while the paint is still wet.

Another method of creating highlights is by gently removing the colour from a wash while it is still wet, using a soft brush, a sponge or a tissue. This technique, called "lifting out", is useful for creating softer, more diffused highlights such as the white tops of cumulus clouds. However, it is not always possible to regain the white of the paper with this method; some watercolour pigments, such as alizarin crimson and sap green, actually stain the paper and so will always leave a residue of colour. Always use a blot-and-lift motion when lifting out - rubbing may damage the surface of the paper.

Small highlights which are difficult to reserve can be achieved by masking the area prior to painting (see pages 34–39), or by adding opaque Chinese white or gouache paint in the final stages of the painting.

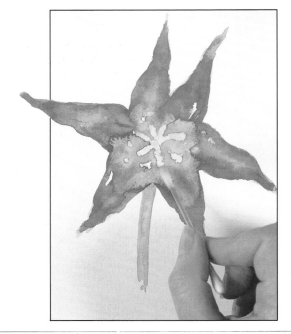

A moistened cotton bud (swab) is an excellent tool for lifting out small areas of colour in a painting. Stroke the colour out gently, working in one direction only to avoid damaging the paper surface.

STILL LIFE WITH FRUIT

1

With a soft pencil make a careful outline drawing of the still life, including the pattern on the vase and cloth.

Materials and Equipment
• SHEET OF 300GSM (140LB) NOT (COLD-PRESSED) SURFACE WATERCOLOUR PAPER, STRETCHED • SOFT PENCIL • KNEADED PUTTY ERASER • WATERCOLOUR BRUSH: 13MM (1/2IN) FLAT • WATERCOLOUR PAINTS: FRENCH ULTRAMARINE, PAYNE'S GREY, INDIGO, ALIZARIN CRIMSON, HOOKER'S GREEN NO.2, RAW UMBER, NEW GAMBOGE, BURNT SIENNA, YELLOW OCHRE, CADMIUM RED, WARM SEPIA AND PURPLE • SOFT BRUSH, SPONGE OR TISSUES

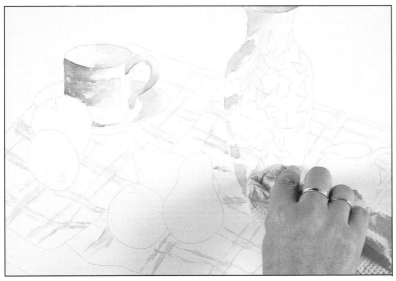

2

Mix a very pale wash of ultramarine and a hint of Payne's grey and begin painting the shadows and the pattern on the cup and saucer. Where the shadows fade out, lift out some of the colour with a clean soft brush, sponge or tissue. Use the same colour for the checked pattern on the tablecloth. Paint the shadows on the vase with indigo and a touch of Payne's grey. Blot the colour with a tissue if it looks too strong.

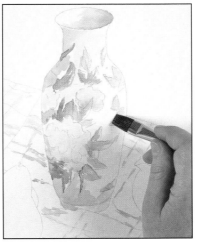

3

Paint the pink flowers on the vase with a pale wash of alizarin crimson. For the dark leaves use Hooker's green no.2, adding a little raw umber to the mix for the lighter greens.

4

Paint the lemon with a pale wash of new gamboge, leaving white highlights on the top surface. Darken the end of the lemon with a hint of burnt sienna. Prepare a slightly darker mix of ultramarine and Payne's grey and deepen some of the shadows on the cup and saucer, taking care to keep the brightest highlights, such as the one inside the cup, clean.

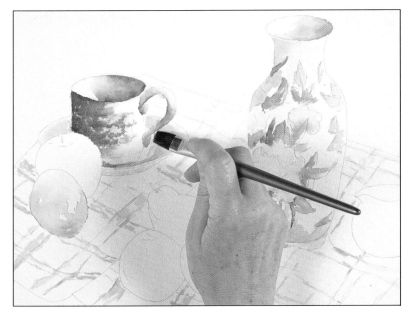

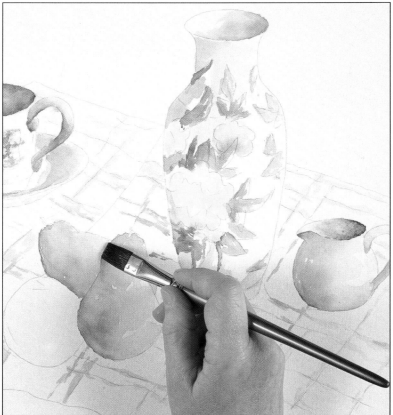

5

Paint the little brown jug on the right with a pale wash of yellow ochre and Payne's grey, darkened with more Payne's grey in the shadow areas. Mix a pale wash of raw umber and paint the pears, working carefully around the sharp highlights. While this wash is still wet, add touches of Hooker's green no.2 in places to vary the tones and suggest the forms of the pears.

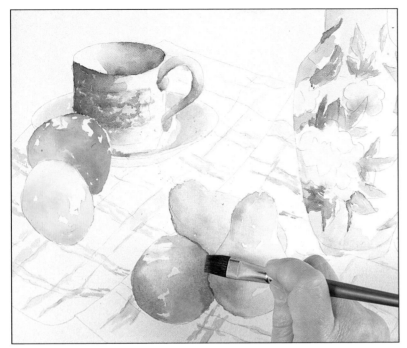

6

When the pears are completely dry, paint the red apples; apply separate strokes of dilute cadmium red and slightly stronger alizarin and allow the two tones to merge where they meet, thus suggesting the rounded forms of the apples. Again, work carefully around the white highlights to keep them clean and sharp.

7

Return to the vase and strengthen the colours in the floral pattern with stronger washes of the same colours used in step 3. Leave to dry. Prepare a wash of indigo, ultramarine and Payne's grey, diluted to a medium tone, and strengthen the shadows on the vase; start at the edge and drag the colour into the body of the vase so that it becomes gradually lighter, suggesting its rounded form.

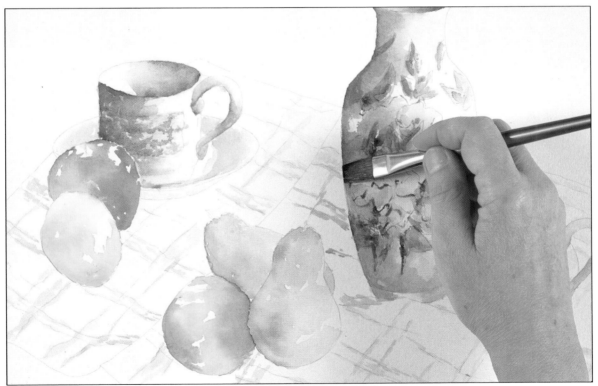

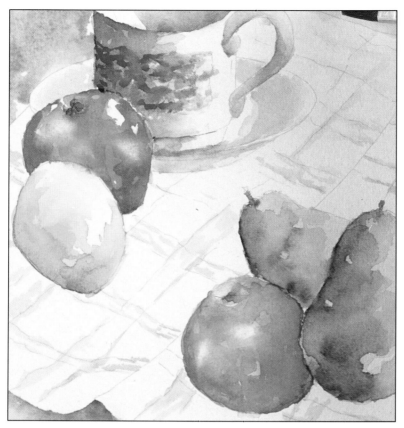

8

Apply further layers of colour to the fruits to build up their forms, allowing each wash to dry before adding the next. Mix burnt sienna and new gamboge for the shadow side of the lemon, adding a hint of Payne's grey for the darkest part. For the apples, apply stronger washes of cadmium red and alizarin; just before the colour dries, lift out one or two soft highlights with a tissue. Strengthen the darks in the pears with washes of Hooker's green no.2, raw umber and ultramarine.

In this close-up detail you can see how the glazes of colour, applied wet-on-dry, suggest the form and volume of the fruits.

9

Strengthen the shadows on the brown jug with washes of warm sepia and Payne's grey. Wash in the background with broad, wet washes carrying alizarin crimson, purple and ultramarine to the right, changing to purple, ultramarine and Payne's grey as you move across to the left. Apply the colours loosely, wet-into-wet (see pages 66–73), and leave tiny speckles of white paper to lend sparkle to the background.

Paint the stalks on the pears with a brown mixed from Hooker's green no.2 and raw umber. Finally, paint the cast shadows on the cloth with a transparent wash of ultramarine, purple and a hint of Payne's grey.

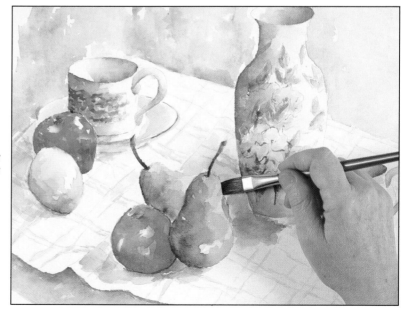

SUPPLIERS

SUPPLIERS

Winsor & Newton
painting and drawing materials
51 Rathbone Place
London W1P 1AB
Tel: 071–636 4231

George Rowney & Co Ltd
painting and drawing materials
12 Percy Street
London W1A 9BP
Tel: 071–636 8241

Russell & Chapple Ltd
general art supplies
23 Monmouth Street
London WC2H 9DD
Tel: 071–836 7521

L Cornelissen & Son Ltd
general art supplies
105 Great Russell Street
London WC1B 3LA
Tel: 071–636 1045

John Mathieson & Co
general art supplies
48 Frederick Street
Edinburgh EH2 1HG
Tel: 031 225 6798

Copystat Cardiff Ltd
general art supplies
44 Charles Street
Cardiff CF1 4EE
Tel: 0222 344422
Tel: 0222 566136 (mail order)

The Two Rivers Paper Company
hand-crafted papers
Pitt Mill

Roadwater
Watchet
Somerset TA23 0QS
Tel: 0984 41028

Falkiner Fine Papers Ltd
watercolour and drawing papers
75 Southampton Row
London WC1B 4AR
Tel: 071–831 1151

Frank Herring & Sons
easels, sketching stools, palettes
27 High West Street
Dorchester
Dorset DT1 1UP
Tel: 0305 264449

Art Supply Warehouse
general art supplies (mail order)
360 Main Avenue
Norwalk
CT 06851
USA
Tel: (800) 243–5038

Artisan/Santa Fe Art Supplies, Inc
general art supplies (mail order)
Canyon Road
Santa Fe
NM 87501
USA

Creative Materials Catalog
general art supplies (mail order)
PO Box 1267
Gatesburg
IL 61401
USA
Tel: (800) 447–8192

Hofcraft
general art supplies (mail order)
PO Box 1791
Grand Rapids
MI 49501
USA
Tel: (800) 435–7554

Pearl Paints
general art supplies (mail order)
308 Canal Street
New York
NY 10013–2572
USA
Tel: (800) 451–7327

MANUFACTURERS

Winsor & Newton
painting and drawing materials
Whitefriars Avenue
Wealdstone
Harrow
Middx HA3 5RH
Tel: 081–427 4343

Daler-Rowney Ltd
painting and drawing materials
PO Box 10
Southern Industrial Estate
Bracknell
Berks RG12 8ST
Tel: 0344 42621

INDEX

PICTURE CREDITS
The author and publishers would like to thank the following for permission to reproduce additional photographs:

Chris Beetles Ltd, London: pages 22, 24 t, 27 t b, 29 t. **The Bridgeman Art Library, London:** page 6 (Albertina Graphic Collection, Vienna). **Visual Arts Library:** pages 7 (Tate Gallery), 8 (Victoria & Albert), 9 (Chicago Art Institute).